U0076774

東京職人

Beretta P-05　雷鳥社

江戸唐紙

前言

受到職人們的守護並流傳至今的傳統、技術、美學、以及精神……

有些事物是即使歲月不斷推移，也想留存下來的。

本書便應運而生。

您知道，在東京都內有40種產業被指定為傳統工藝品嗎？傳統工藝品的認定標準為：主體需為手工製作、使用流傳至今的傳統原料、都內有4間以上的企業從事製造等，標準相當嚴格。

本書集結東京都政府指定的40種傳統工藝品之49位職人們，由年輕且衝勁十足的攝影師團隊多次造訪、取材、攝影而成。

堅持此行數十年，累積修行，對於傳統一點也不馬虎，磨練自身技術和精神的職人們。出類拔萃、連細部都相當講究的美麗工藝品。以及，平時難得見到的工作內幕、職人們偶爾露出的溫柔神情……由攝影師們熱情地、深情地、且牢牢地捕捉了下來。

繼承者不足、關係企業倒閉等，傳統工藝的現狀可以說是相當艱難……。但是，只要由這些職人們竭力製作出來的優質「真品」還在，傳統工藝一定可以繼續延續下去。

若未將這些傳統工藝品實際拿在手上或親身使用看看的話，是不知道好壞的。我們希望讀者不只是透過照片欣賞，而是能試著理解他們所注視的、用肌膚感受的所謂「傳統」的這個真品世界。

希望本書能成為這些傳統繼續被守護並傳承下去的一點助力。

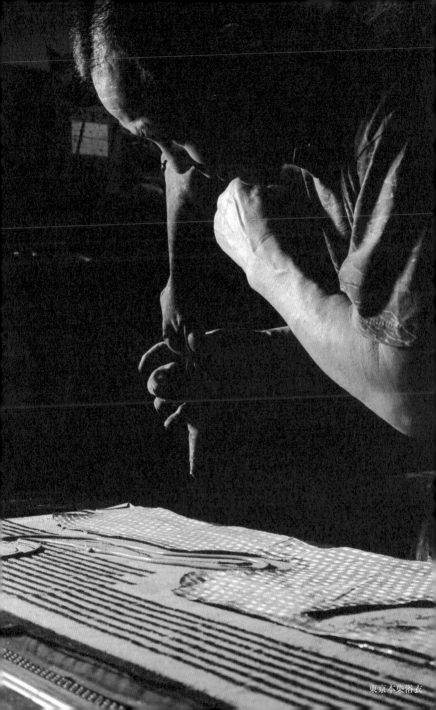

東京本染浴衣

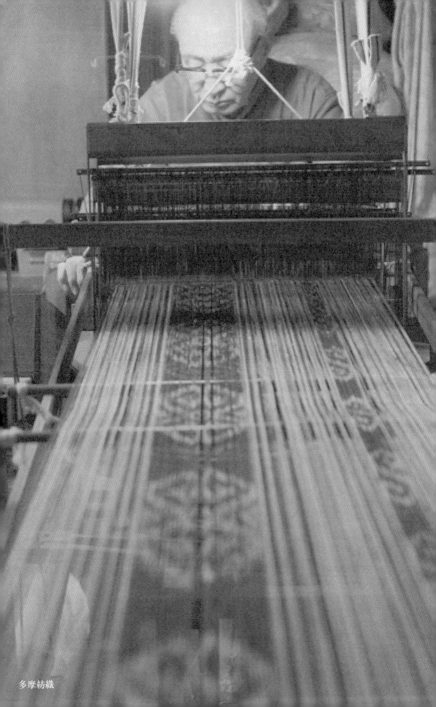

多摩紡織

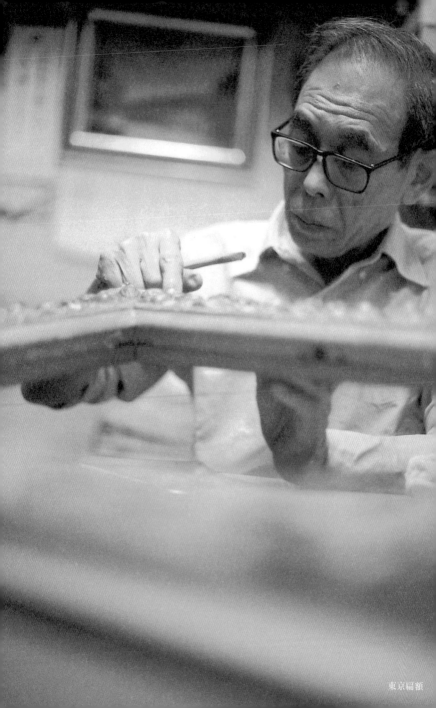

東京扇額

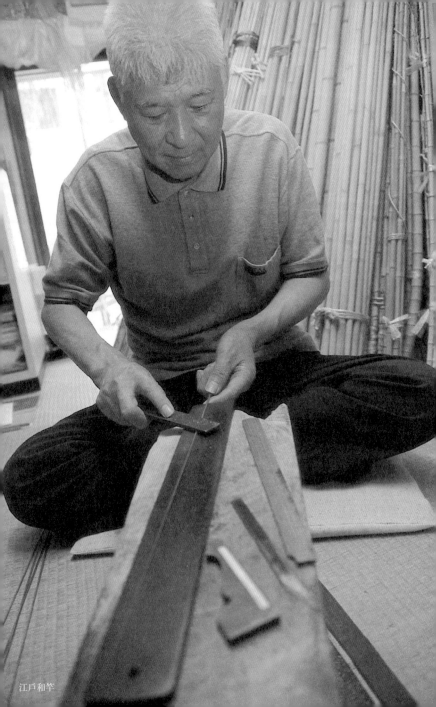

江戸和竿

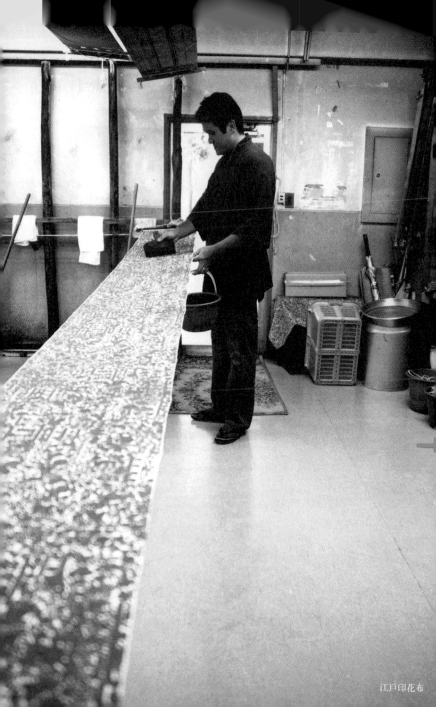

江戶印花布

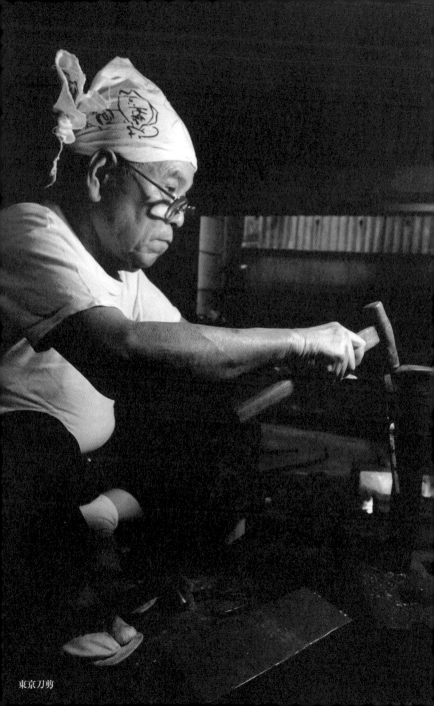

東京刀剪

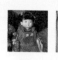

村山大島捻線綢

村山大島捻線綢始於江戶時代後期。1920年左右，村山大島捻線綢成為主要生產的絹織品。由正藍染製成的棉織物——村山紺絣、以玉繭製成的絹織物——砂川太織兩者合併而成。

光滑的色澤以及良好的觸感，民藝調的風格加上正絹的優雅，不分正反面正是其特徵。

因獲得高度評價，於昭和42年被指定為東京都指定無形文化財，昭和50年則是受到經濟產業省傳統工藝品認定。

Murayama Oshima-tsumugi craftsmanship weaves silk and cotton cloth into superb kimono, hapi, haori jackets and other traditional Japanese textile artistry. From the time Oshima-tsumugi silk kimonos first appeared in what is now Tokyo toward the end of the Edo Period, they have been known for their glossy look, smooth feel, traditional, refined taste, and signature either-direction fabric designs that can be worn front or back. In 1967, the Tokyo Metropolitan Government declared Oshima-tsumugi woven goods an intangible cultural asset.

MURAYAMA OSHIMA TSUMUGI

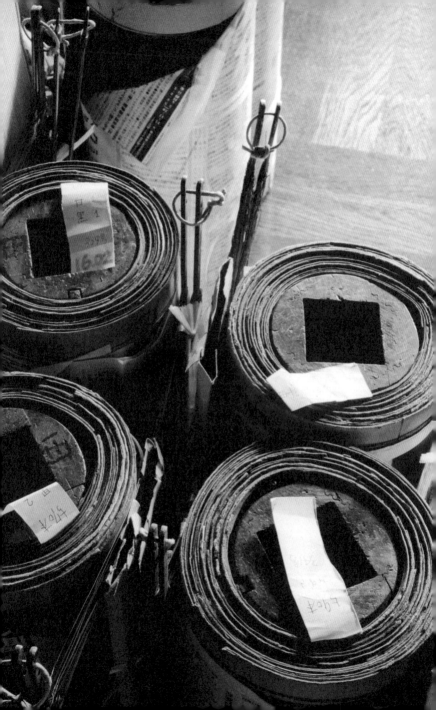

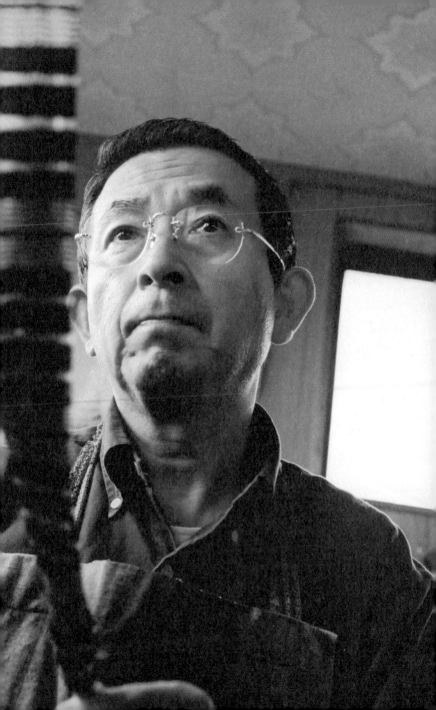

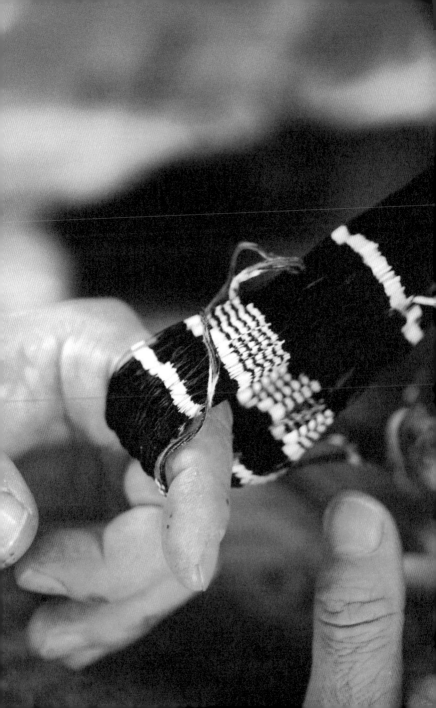

田房染織有限会社
田代隆久（たしろ たかひさ）

從學生時代開始便對織品製造業相當感興趣，因此入行。師事村山大島捻線綢傳統工藝士的父親‧田代悅康。平成2年其繼承家業田房染織有限会社。平成6年其技術受到肯定，成為日本傳統工藝士。抱持著希望透過村山大島捻線綢，將日本的文化傳達給後世的強烈心念，努力埋頭工作。發揮村山大島捻線綢的特徵，卻不受既定概念所影響，運用自由的想像力，持續進行創作活動。

Takahisa Tashiro, Tokyo's leading Oshima-tsumugi craftsman, began developing his lifelong interest in fabric and clothing construction as a schoolboy, when he started at the family kimono weaving factory. Tutored in the textile arts by his artisan father, he took over the kimono business in 1965. The Tokyo Metropolitan Government officially recognized his mastery in 1994, when it named him a certified Traditional Craftsman.

P18
村山大島捻線綢在完成之前大致可分為9個工程。正在進行第7個工程「すり込捺印」的田代先生。

田房染織有限会社
東京都武蔵村山市三ツ木 2-46-1

Photo/ 押尾曉子

東京染小紋

染小紋的歷史始於室町時代，江戶時代則因武士的正裝上採用了染小紋而廣為流行。染小紋經過雕刻紙型、調整色漿、定型布料、染底色、蒸、水洗、乾燥等步驟製作而成。

江戶時代中期以後也開始普及於平民之間，受到自由又時髦的風格洗禮，直到今日，染小紋變得更加洗練。

東京染小紋，是指在東京進行以錐子與小刀雕出圖樣的「型彫り」的工序，之後染色而成的製品。

Tokyo some-komon (fine-pattern stencil dyeing) uses traditional Japanese stencils to create dotted patterns of extremely fine detail. These pinpoint stencil patterns were first used in warriors' formal dress called kamishiro during in the Muromachi Period. Later, in the middle of the Edo Period, some-komon patterns became more widely used by common people. The fine-pattern stencil dyes are seen today in women's "visiting" kimonos.

TOKYO SOMEKOMON

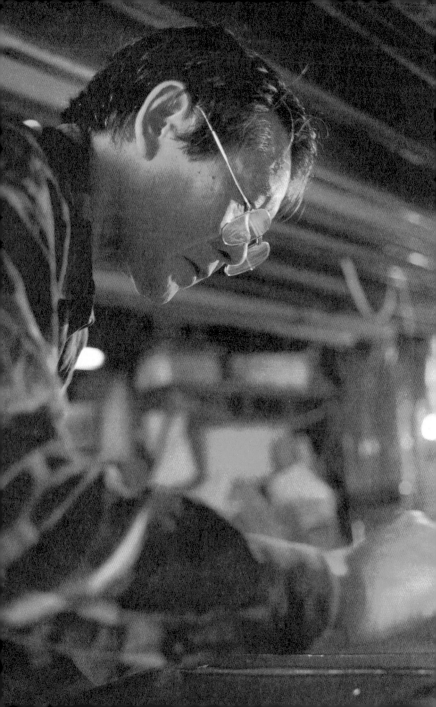

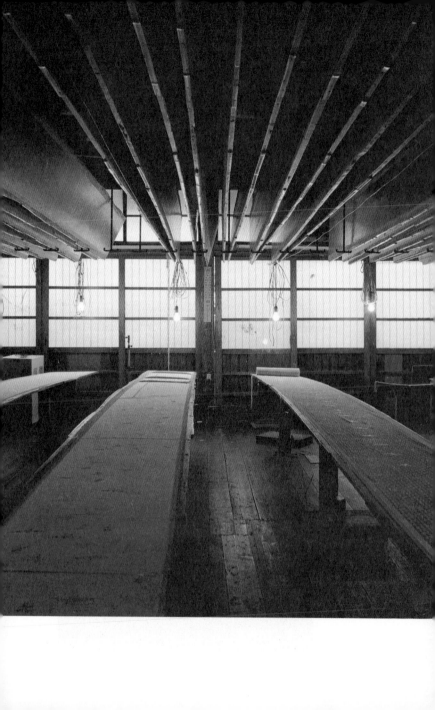

富田染工芸 型染部門
佐藤勇三 (さとう ゆうぞう)

在大正3年創業的老舖——富田染工芸店裡專事紙型印染的佐藤勇三（創作筆名佐藤雄三）。擁有40年以上的資歷，其手法只能說絕妙出色。身為新宿這個新都心的當地產業之傳統工藝士，肩負著將始於自江戶時代的傳統技術及時髦感傳承至今日。最新作品有以日本三大景為題材的「安芸の宮島」等。

In 1914 the venerable dyehouse Tomita Somekogei moved to specialize in katazome, a design form in which sticky ingredients are pushed through a stencil to define a pattern. Yuzan Sato, the current Tomita Somekogei dye master, produces elegant work borne of his 40-year plus career. As the latest in a line of traditional craftsmen in one of Shinjuku's key local industries, he keeps both the techniques and sense of style from the Edo Period alive in modern-day Japan.

富田染工芸
東京都新宿区西早稲田 3-6-14
TEL：03-3987-0701

Photo/ 奥田善彦

本場黃八丈

黃八丈為八丈島的傳統絹織品，據說也是島名的由來。1977年被指定為日本傳統工藝品，1984年山下めゆ則獲東京都認定為無形文化財。以生長在八丈島的草木作為天然染料，將染成「黃」「樺（譯註：偏紅的黃色）」「黑」等三色的線搭配組合，手工織成直條紋、格紋等花色。特徵是經過長年累月也不會變色，反而越洗是越鮮豔。

Kihachijo cloth, named after Hachijo Island, is an elegant dyed fabric for traditional kimono and obi, which was designated a Traditional Handicraft by the Ministry of Economy, Trade and Industry in 1977. In creating kihachijo, the dyestuff is extracted from dried island vegetation known as kobunagusa and transferred to thread, which is then hand-woven into the final cloth. Renowned for its colorfastness, the kihachijo coloration becomes more vivid the more it is washed.

HONBA KIHACHIJO

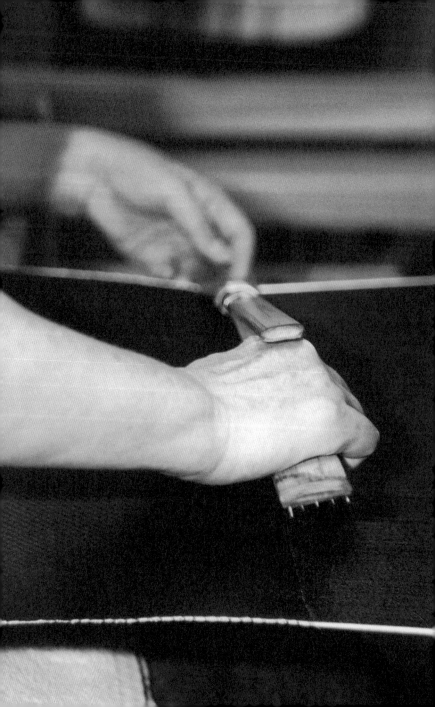

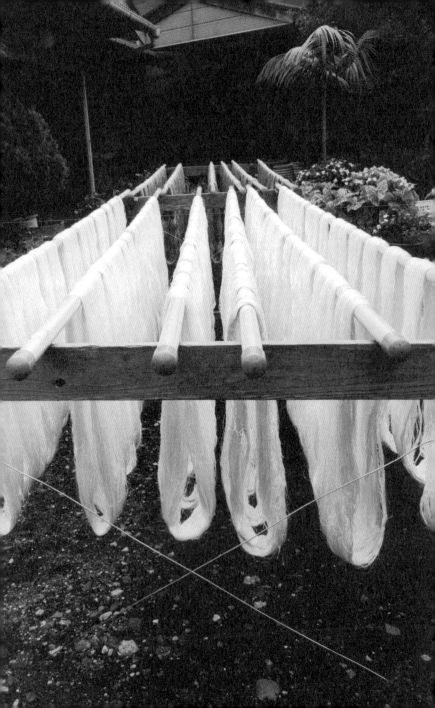

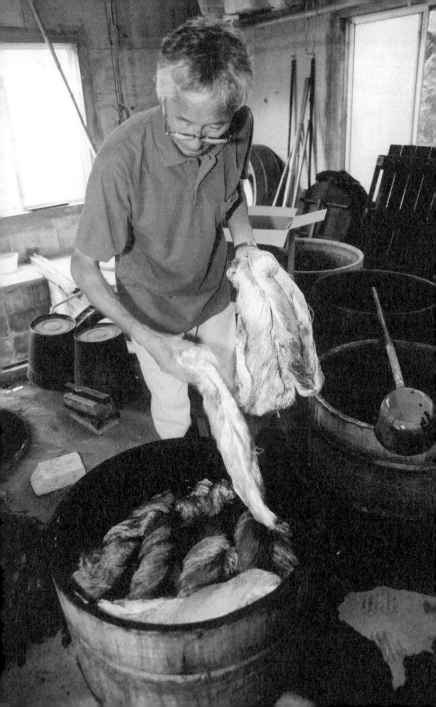

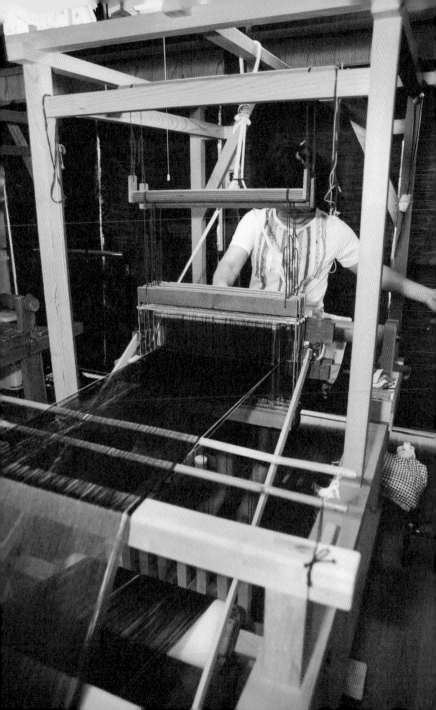

黃八丈めゆ工房
山下 誉 (やました ほまれ) ／山下芙美子 (やました ふみこ)

染匠‧山下譽染製出的顏色相當亮麗，徹底顛覆了原本草木染的印象。山下譽繼承了黃八丈的傳統，為了將此歷史傳給後世，除了在大學擔任臨時講師，也在工坊教授造訪八丈島的旅客關於黃八丈的知識。芙美子則是織匠。母親為東京無形文化財的山下めゆ。進行織物工作時，手腳的一丁點動作都會影響到布料的好壞，既複雜又一點都不得馬虎。線的配色以及花色配置也講求美感。織好的布料毫無間隙，相當完美。只拿來做日常服飾實在很是奢侈。

Dye master Homare Yamashita oversees the dyeing process at the kihachijo workshop where the cloth is produced. His technique helps fabrics achieve a rich, brilliant coloration that takes natural plant dyeing to a new level. The weaver, Fumiko Yamashita, then spins the kimono fabric to life. Together, they produce sophisticated color patterns and designs for products characterized by their perfect workmanship. Their mother, Meyu Yamashita, possesses a level of expertise so high that the Tokyo Metropolitan Government has declared her skills an intangible cultural asset.

黃八丈めゆ工房
東京都八丈島八丈町中之郷 2542
TEL：04996-7-0411

Photo/ 古宮美紀

江戶木紋鑲嵌人偶

始於1740年左右，製作京都上賀茂神社的奉納箱的職人，以剩餘的木片製成木紋鑲嵌人偶。

在木製的人偶身體上雕出木紋後，再將和服布鑲入，因而被稱為「木紋鑲嵌人偶」。此技巧傳到江戶後，便成為江戶木紋鑲嵌人偶。

現在除了木材以外，也開始使用桐塑。頭與手腳則是使用素燒。

A craftsman serving in a shrine in Kyoto around 1740 created items such as wooden boxes for monetary offerings, and saved the leftover wood. He used the willow wood scraps to carve the first kimekomi-literally, tuck-in-dolls. After creating the doll body, edges of fabric material are tucked in to the grain of the wood from which the little doll is carved. This unique doll-making technique eventually spread to Edo, where it was popularized as the Edo kimekomi style.

EDO KIMEKOMININGYO

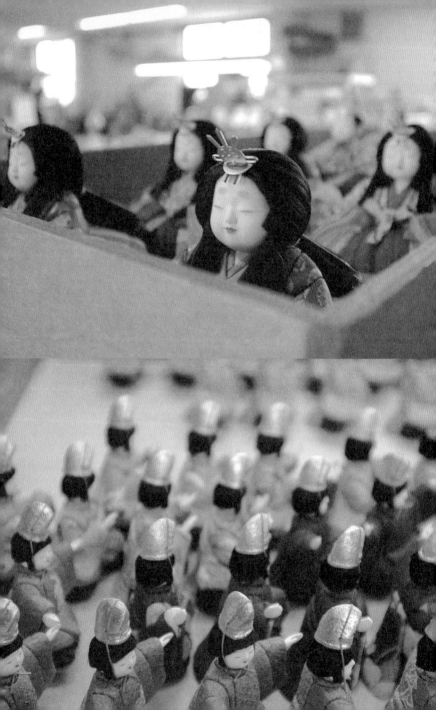

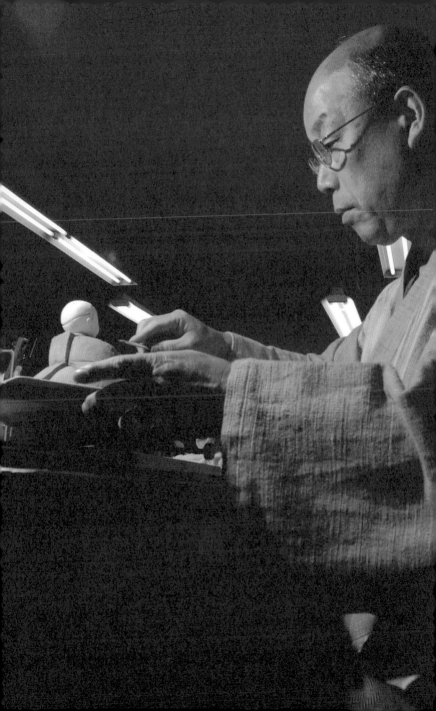

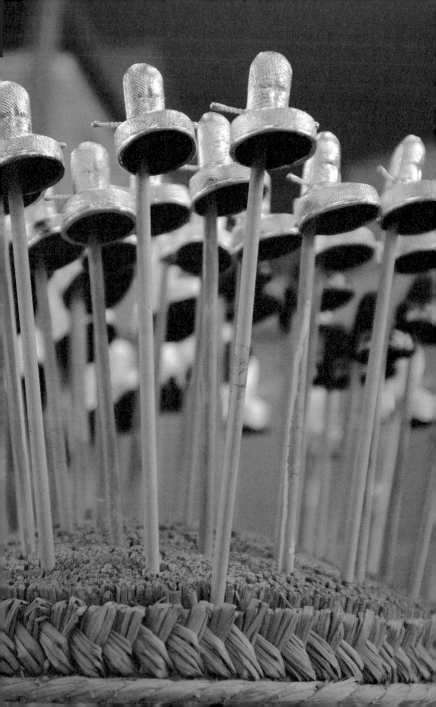

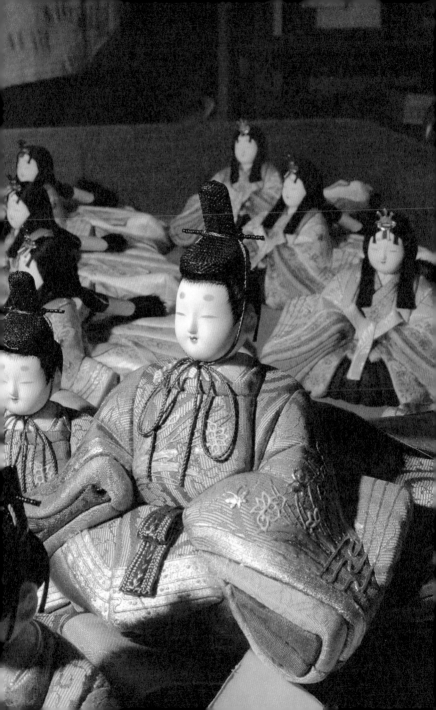

株式会社柿沼人形
柿沼正志（かきぬま まさし）

昭和23年9月於東京出生。昭和49年師事其父柿沼東光後，便專心致志於人偶製作。平成11年獲得通產大臣認定傳統工藝士之認證，平成12年則獲東京都知事認定為傳統工藝士。多次展示綴有華麗色彩的親王飾及設計獨特的五月人偶。共獲3次內閣總理大臣賞、4次通產大臣賞、1次東京都知事賞等多數獎項，至今仍相當活躍。

Masashi Kakinuma, one of today's greatest doll-making masters, learned the trade from his father and began specializing in kimekomi in 1974. By 1999, he was certified a Traditional Craftsman by the Minister of Economy, Trade and Industry, followed a year later with similar recognition from the Governor of Tokyo. His uniquely designed and beautifully colored dolls have been displayed in a succession of exhibitions, winning numerous awards.

株式会社柿沼人形
本社：東京都荒川区西尾久 2-1-5　TEL：048-964-7877
http://www.kakinuma-ningyo.com/
e-mail:kakinuma-ningyo@nifty.com

Photo/ 水島大介　Assistant / 寒河江怜子

江戶木紋瓖嵌人偶

始於江戶時代中期的京都，傳到江戶後變得更多樣化和精緻化，進而發展成現今的江戶木紋瓖嵌人偶。

木紋瓖嵌人偶，是用桐木木糠拌入生麩糊而成的桐塑，製作人偶原型，然後在上面刻出木紋，並鑲入布料。

因原型可任意製作，所以是種既可展現職人的技巧與特色，又同時保有傳統形式的人偶。小型的也相當有格調，雛人偶、干支人偶等皆長久受到好評。

Today's kimekomi doll figures are usually made of sawdust blended with jute fiber and glue. Silk brocade or other varieties of cloth are glued and tucked into the grooves of the body to produce the final doll. Although the craft is imbued with a sense of tradition and prestige, it also gives each craftsman free play in expressing his skill, artistry, and individuality, since the doll pattern is different for every kimekomi. The dolls are favorites for hina-ningyo Girls' Festival displays.

EDO KIMEKOMININGYO

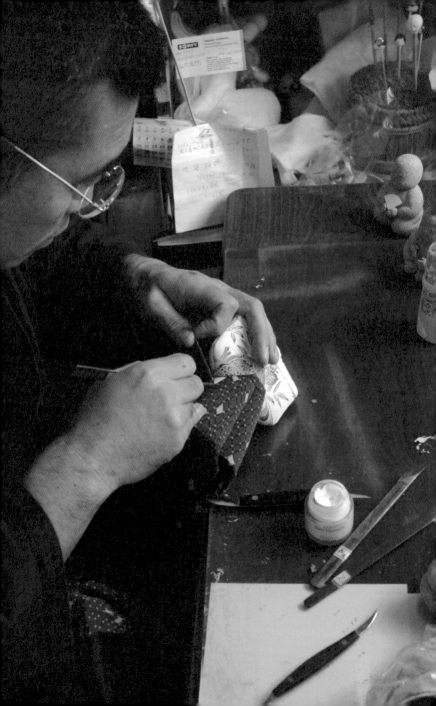

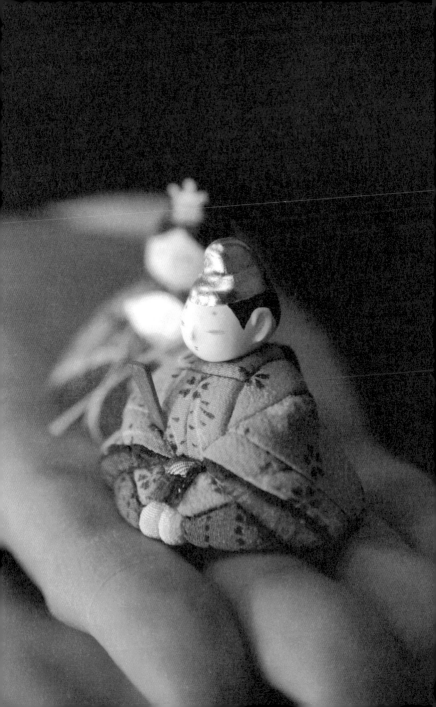

塚田工房

塚田 進（つかだ すすむ）

塚田進於昭和24年出生於東京都墨田區，是少數同時擁有東京都傳統工藝士
與通商產業大臣傳統工藝士資格的名匠（雅號：詠春）。同時也是人偶職人
的他，秉持著「沒有專精全部的製作工程，便不能將人偶注入生命」，因此
從製作原型到完成都是自己包辦。至今仍在研究各式各樣的人偶，期望能發
揮木紋瓖嵌的技術，製作富有個性的人偶。

Born in Tokyo's Sumida Ward in 1949, Susumu Tsukada went on to
become a premiere doll-making artist and craftsman, one of very few
recognized as a Traditional Craftsman by both the Ministry of
Economy, Trade and Industry and the Tokyo Metropolitan Government.
He continues working to bring his expertise to life in his dolls, the
embodiment of his unique aesthetic vision.

P40
人偶身上所穿的衣裳為從歷史悠久的和服上所拆解下來的古布。年代越久，越有味道，
也更有格調。

P42
約手掌大小的雛人偶是備受喜愛的名品。

塚田工房
東京都墨田区向島 2-11-7
TEL：03-3622-4579　http://www.edokimekomi.com

Photo/ 伊藤尚子

東京銀器

東京銀器始於江戶中期左右，雕刻師橫谷宗明為了製作商人的道具，改變了技術技法。以敲擊金屬板使之延展或收縮的「鍛金」技法，讓金屬板立體成型後，再加上裝飾便是東京銀器。

敲擊金屬所發出的輕快音調響徹工房。並非用眼睛看，而是一邊確認聲音，一邊讓一片銀板變身成一件毫無接縫的器具。

Tokyo silver work (ginki) started with engraver Somin Yokoya. He pioneered what was then breakthrough smithing technology to produce utensils for the townsfolk in the mid-Edo Period. Tokyo silver work involves hammering out sheet metal, then shrinking it in a plating process, a traditional method referred to as tankin. The tankin style allows molding and decorating the metal in the same process.

TOKYO GINKI

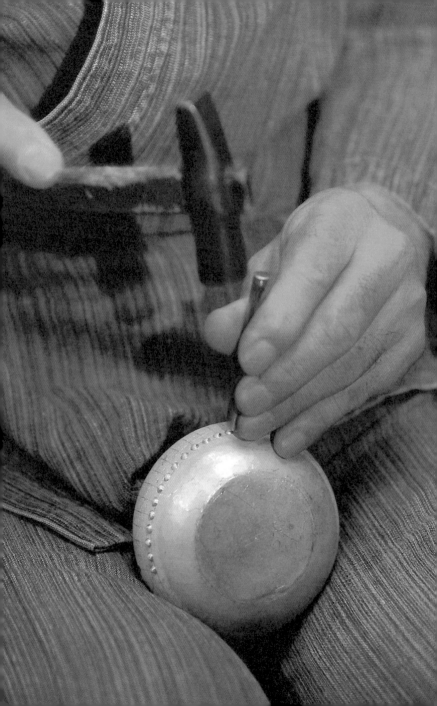

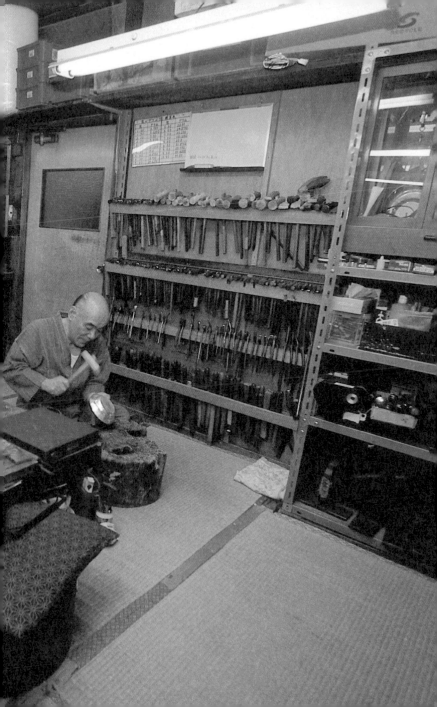

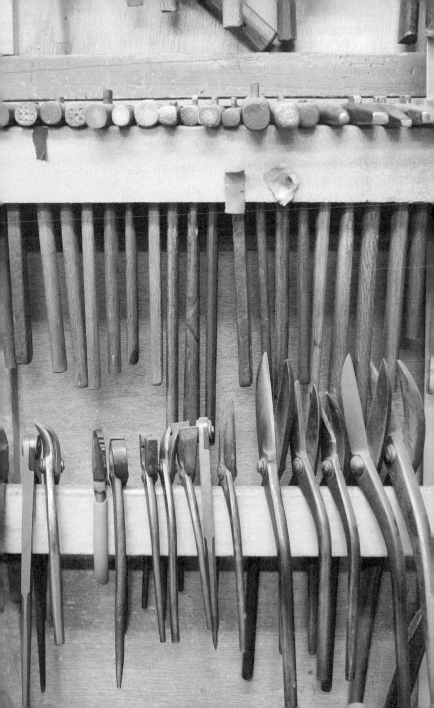

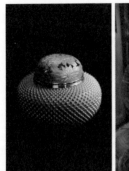
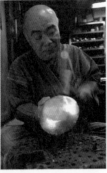

東浦銀器製作所

石黒光南 (いしぐろ こうなん)

「霰打ち」是種在銀板的內側墊著凸型金屬零件，從外側用凹型槌一一敲出顆粒的技法。此技法包含光南（本名：照雄）先生在內，只有3人才做得到。因為「霰打ち」時必須集中精神，據說都是一個人在深夜進行。平時，工房裡有6位學徒一同製作銀器，但還有許多人正排隊等著進門。製作銀器的道具也是由職人所造。工房內有許多道具是從上一代，也就是職人的父親那裡繼承而來。

Few if any artisans can match the silver handiwork of Konan Ishiguro, but many would like to try. At present, there are six apprentices working under him, but the waiting list for the position is longer. Ishiguro creates his own silversmith's tools, which rest next to the set he inherited from his father in the workshop.

東浦銀器製作所

文京区弥生 2-20-6　TEL：03-3813-2241

光南ショールーム：東京都文京区根津 1-17-6 谷川ビル 1F

TEL：03-5814-2035

Photo/ 鴨志田順子

東京手繪友禪

友禪染為江戶時代的享保年間（1684～1687年）時，由京都的繪師——宮崎友禪所創。

到了江戶時代的文化・文政期（1804～1827年），江戶成為武家政治的中心，文化與經濟發展興盛，友禪染的技術也隨著從關西傳來的產物一同傳入江戶。

有別於京都的高雅，江戶則是誕生了時髦且別緻的花紋及色調。這就是東京手繪友禪。

The tegaki yuzen method of drawing elaborate designs on silk is named for Yuzensai Miyazaki, the Kyoto painter who perfected the style during the Edo Period. This dyeing technique migrated from Kansai to Edo along with the commodities it decorated. Edo aesthetic sensibilities were reflected in chic, sophisticated designs, a divergence from the Kyoto miyabi conception of elegance that had informed the style to that time. Hand-drawn patterns with this more colorful flair came to be known as Tokyo tegaki yuzen.

TOKYO TEGAKI YUZEN

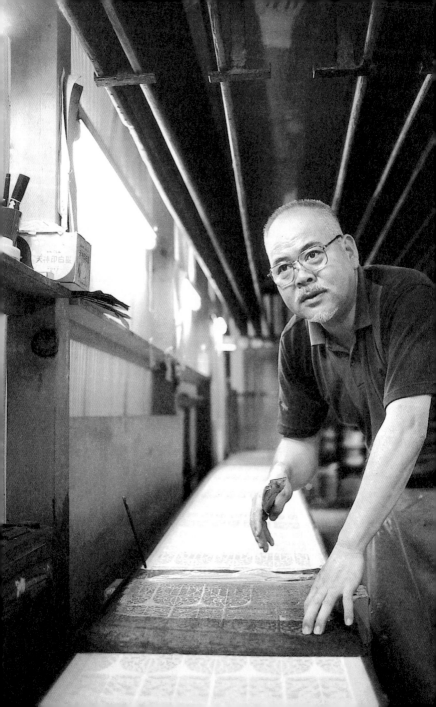

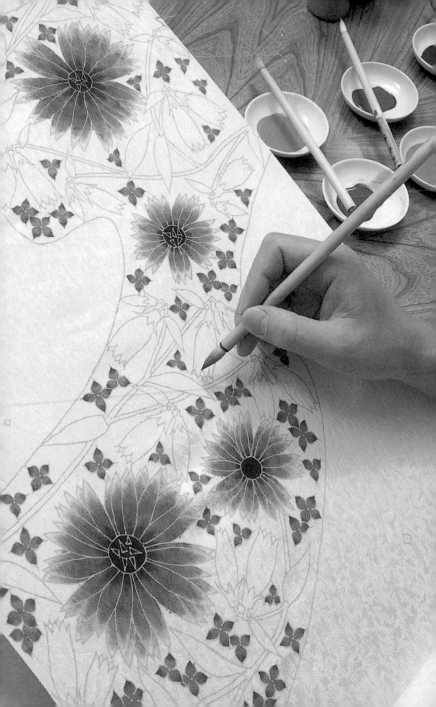

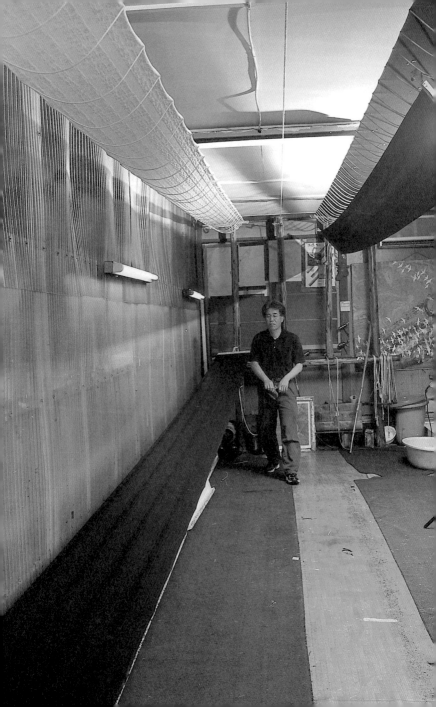

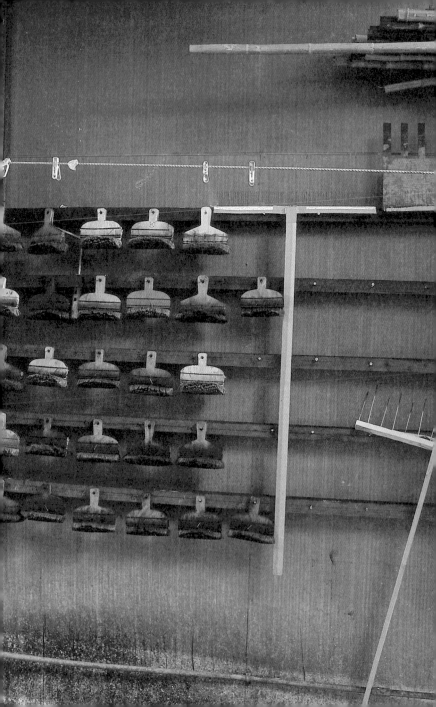

染の高孝　高橋孝之（たかはし たかゆき）

東京都工藝染色協同協會常任理事。高橋先生的工房內有板場（譯註：將底布撲在板子上後以紙型染色）跟張り場（譯註：將底布撐開後以刷毛染色），可以進行全部的作業。除了手繪友禪，也運用江戶印花布、一珍染、木目染、墨流染等技術，製作和服及腰帶，以及洋服等的布料。在東京，只有高橋先生的工房使用以小麥粉製作的一珍糊。與京友禪、加賀友禪不同，可以製作出較有個性的作品為其魅力。

Takayuki Takahashi, a tegaki yuzen artist, is also a second-generation member of the Tokyo Tegaki Yuzen Executive Board. In addition to the tegaki yuzen, his prolific workshop produces obi and kimono with Edo sarasa style dyed silk, as well as icchin zome designs. Of the techniques the studio employs, the icchin flour paste dyeing is perhaps the most unusual-only one workshop in Tokyo is using it. The individual personality reflected in each piece is the key source of attraction running through the variety of production methods and artifacts.

染の高孝

東京都新宿区高田馬場 3-9-1　　TEL：03-3368-7388

Photo/ 今井大子

多摩紡織

多摩紡織為流傳於多摩川旁的八王子市、秋留野市的傳統工藝。從前，此區被稱為桑之都，因應江戶的不同需求，生產了許多種類的絹織品。現在，御召織、捻線綢織、風通織、變綴、綟織等5種織法皆屬多摩紡織。多摩紡織是種越穿越舒適的織品。過去不僅受到東京下町的太太們喜愛，一流的藝伎也以此做為日常服。毫不在意地將奢侈的絲絹穿在身上，相當時髦。

Tamaori (Tama fabric work) is the generic name for the traditional handicraft centered in Akiruno-shi, Hachioji, encompassing five different types of weave: omeshiori, tsumugiori, futsuori, kawaritsuzure, and mojiriori. Stylistically, these range from intricate tapestries to pre-twisted woven cloths, twills, and more complex satin weaves. Tamaori kimonos are durable, and get more and more comfortable with every wearing. They have traditionally been considered the height of sophisticated fashion, favored by the top geisha.

TAMAORI

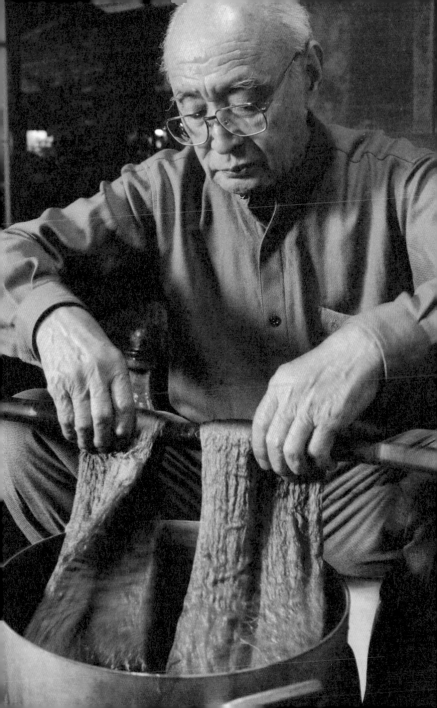

有限会社澤井織物工場

澤井栄一郎（さわい えいいちろう）

1921年出生。從祖父開始算起，為多摩紡織職人第三代。從戰場上歸來後，以僅存的3台織布機繼承家業。批賣給眼光相當高的銀座與新橋的專門店，為了對應顧客挑惕的要求，除了磨練傳統技術，也致力於改良，提升品質。不會起皺折及變形的和服作品相當受到好評。也時常用於能劇及歌舞伎等傳統藝能。澤井家族裡有多位藝術家，攜手讓多摩紡織的傳統保留到今日。

Eiichiro Sawai, a third-generation master weaver, was born in 1921. He returned from the war to take over the family business, successfully building it back into a thriving kimono factory from the three looms remaining at war's end. Wrinkle-free, comfortable Tama kimonos have always been renowned for the ease of movement they offer. They are often used in traditional performances such as noh and kabuki.

P57
據說「咚咚鏘嘟鏘嘟」的機器聲代替了搖籃曲陪他長大。一反（譯註：約11米）的布需要1個月的製作時間。

P58
將生絲「先練り」（精煉絲絹，將不純物去除）以及「先染め」（將絲染色後再織）為多摩紡織的特色。

有限会社澤井織物工場
東京都八王子市高月町1181　TEL：0426-91-1032

Photo/ 松原容子

東京編織絲帶

編織絲帶（譯註：以細絹線或棉線編織而成的繩帶）的歷史相當長久，用途多樣，除了固定及扣緊物品，打結的方法、繩結的顏色、結的配置等也可以表示出吉凶、性別、身份等。穿著和服時用來束緊腰帶的帶締及用來固定羽織的編繩等，如今在日本人的日常生活中也經常使用到。

東京編織絲帶因曾做為兵器的一部分，線與線交錯的接縫處做得相當堅固扎實為一大特徵。另外，其素雅的配色，乃是時髦的江戶風格之象徵。

The art of kumihimo braiding traces back more than a thousand years. Over that period, artisans and craftsmen have developed a wide diversity of uses beyond merely securing and fastening objects. In its decorative role, the position and color of the kumihimo have historically been used to symbolize gender, indicate the rank of officials-even tell fortunes. The braids remain a part of everyday life in Japan today, serving as obijime to secure the obi sashes worn with kimono, or as short cords to fasten haori jackets in the front.

TOKYO KUMIHIMO

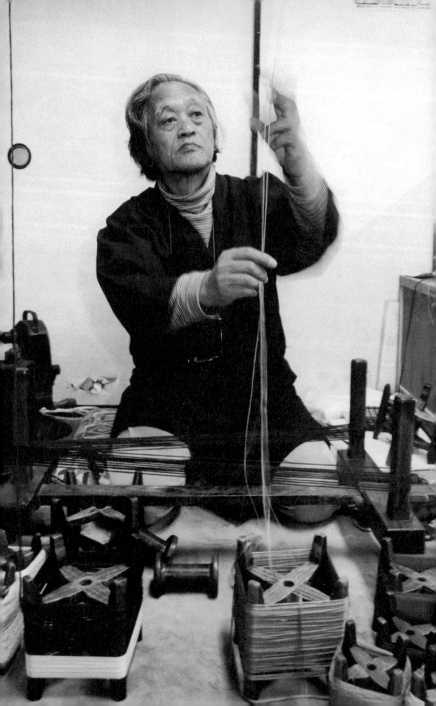

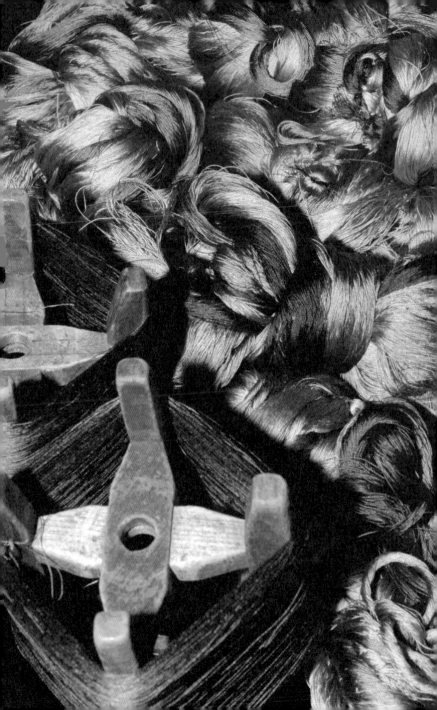

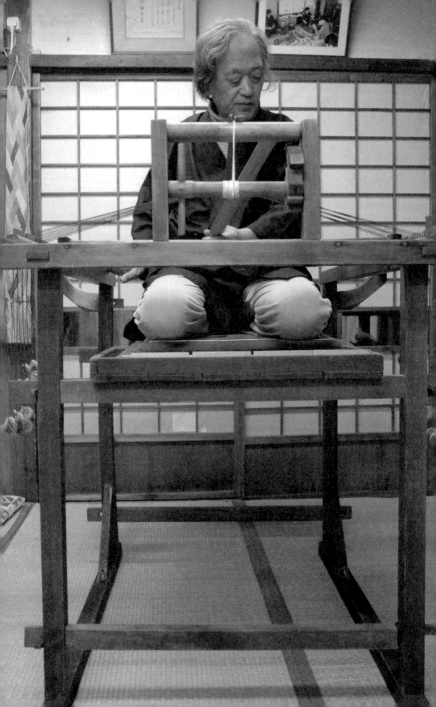

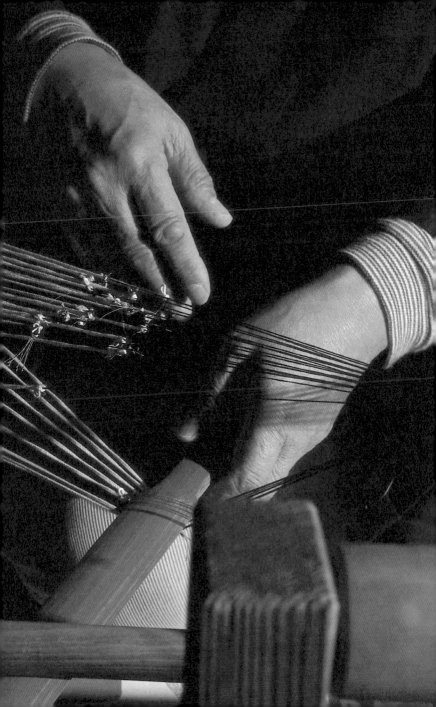

横塚紐工芸
横塚石鳳（よこつか せきほう）

身為編織絲帶師，除了製作編織絲帶外，為了將傳統工藝傳承給下一個世代，也在博物館等地擔任講師，致力於實際講演並教導編織絲帶製造。另外，以學術角度來檢驗，研究使用於鎧甲的編織絲帶種類、技法、製法，並嘗試重現等，在各個方面展現對編織絲帶的熱情。遵循東京編織絲帶的傳統，並以獨特的美感製作出的編織絲帶，不僅是穿搭時的配角，作為主角也毫不遜色。

As one of the nation's most accomplished braiders, kumihimo master Sekiho Yokotsuka naturally spends a great deal of time making the kumihimo artifacts himself, but he is also an ardent advocate for the craft, offering lectures and demonstrations at venues including museums, and sharing his expertise in support of other aspiring artisans. As a researcher and academic, he is absorbed in the study of the different types of kumihimo incorporated in the armor of Japan's ancient warriors, and the techniques and processes used to make them. Thus, the braider finds himself completely interwoven in a passionate relationship with his art.

横塚紐工芸
埼玉県岩槻市本町 1-14-4　TEL：048-758-5553

Photo/ 古宮美紀

江戶漆器

江戶漆器，為堆疊式方盒、飯台、碗等，日常生活中使用的漆器工藝。始於江戶幕府開設時，德川家康招集京都的職人製作日常用品而來。漆器的英文稱為「japan」，是日本歷史悠久的獨特工藝品。一個製品大約要經過7道程序。一連串相當細膩且枯燥的作業，以職人的技術及耐心製作出完美的逸品。

Edo shikki is a type of lacquerwork widely used to finish bowls, trays, boxes and chopsticks. So intimately associated with the spirit of the nation is this lacquer craft that it is known in English as "japan." A variety of techniques exist for building up the lacquer, but since they all require the delicate-and patient-application of layer upon layer, it is the artisan's perseverance as well as his craftsmanship that produces a true shikki gem, a masterful embodiment of the art.

EDO SHIKKI

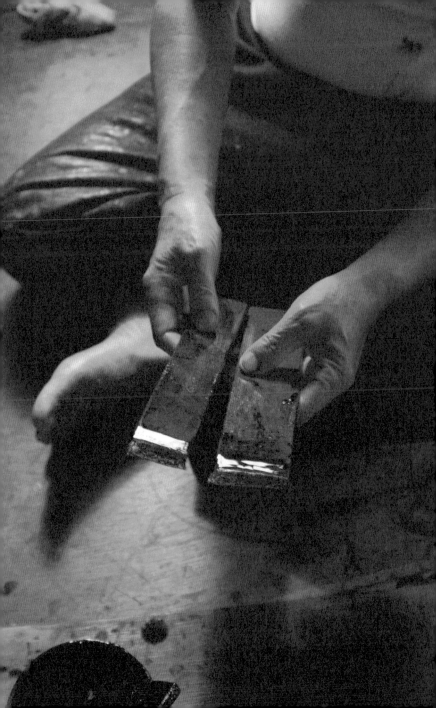

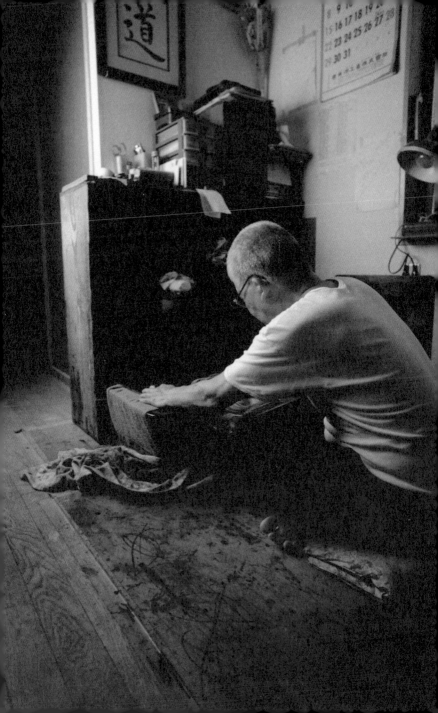

白石漆器
白石敏道 (しらいし としみち)

白石敏道為塗漆的職人。與日常生活有著直接關係，實質意義上是東京最後
一位職人。因堅持自己為職人而非藝術家，絕不為作品命名。「塗漆有無限
的可能，因為不受限於形體，所以可以應用在任何東西上」白石先生如此說
道。自26歲獨立後，使用了42年的塗漆桌上那一層一層的漆，宛如與白石先
生的人生般重疊著。

After plying the shikki craft for some time, one of the nation's top
artisans, Toshimichi Shiraishi, set out on his own at the age of 26. In
describing his attraction to shikki, he points out that "Lacquer is an
infinitely variable medium. It can be applied not only to decorate but
actually create a wide variety of objects." Layering lacquer-glued paper
to the interior of a mold produces rich colored surfaces that can be
further polished and decorated. No simple paint can do that.

P65
塗漆用的刷毛決定漆器的生命。這也是職人親手製作的。

白石漆器
東京都葛飾区四つ木 3-5-2　TEL：03-5671-2346

Photo/ 伊藤明子

江戶鼈甲

充滿光澤的花紋、琥珀色的沉穩色澤及光滑的觸感，有種自然的溫度。使用以此製作的梳子及髮簪，據說可以吸收頭部的熱度，減緩頭痛。

其歷史可追溯到607年，隨著遣隋使傳到日本。江戶時代因加上嶄新的技術，成為廣受歡迎的飾品。不使用接著劑，只使用熱度及水的壓製技術為日本獨創。鼈甲工藝品經由職人熟稔的技術以及適當的保養，據說可以保存100年到200年左右。

Smooth to the touch, with flashes of amber coursing through their characteristic light patterns, Edo bekko tortoise shell artifacts are as attractive as they are distinct. Legend has it that bekko used for women's hair ornaments and combs offers medicinal benefit as well as aesthetic merit, absorbing heat from the head and relieving headaches. Historically, bekko crafts were introduced from China by returning Japanese envoys to the Sui Dynasty in 607. Yet relatively few articles become antiques: artifacts produced by tortoise shell craftsmen are said to remain functional for 100- even 200-years.

EDO BEKKO

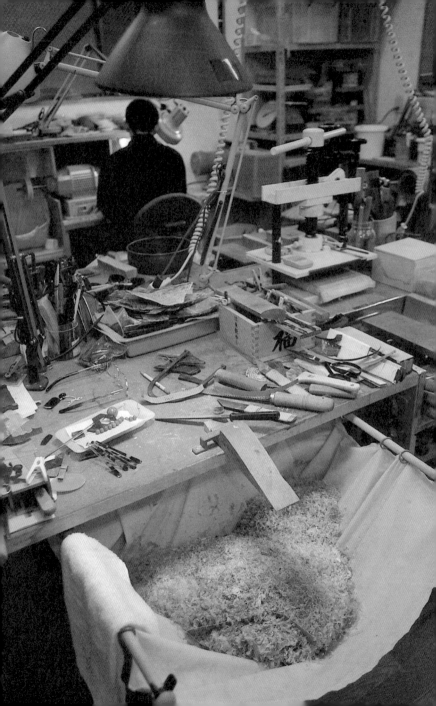

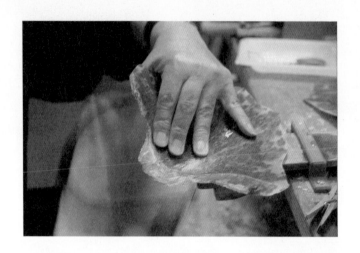

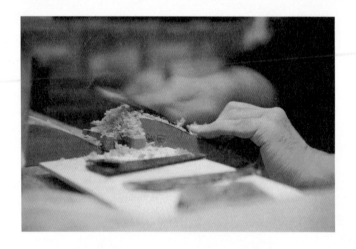

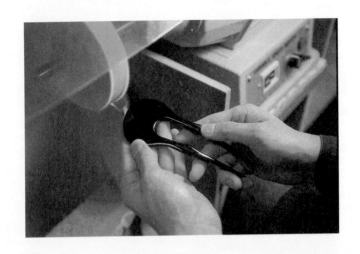

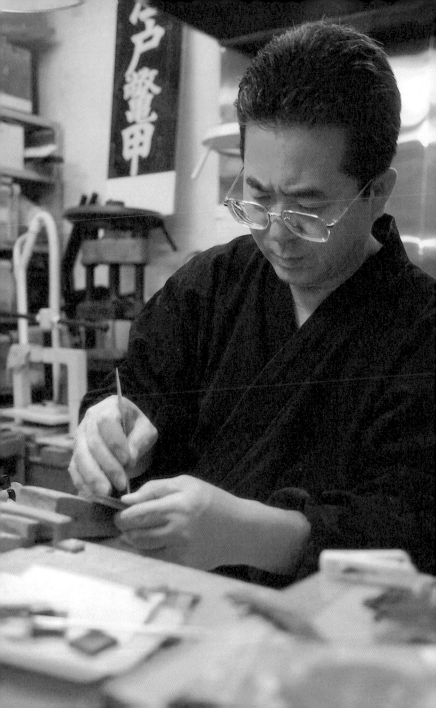

鼈甲磯貝

磯貝實 （いそがい みのる）

91歲的父親，庫太先生也是師傅，曾獲得文化勳章。職人跟隨父親修行，於2002年被認定為江東區無形文化財。雖然走在不同道路上，克實、剛、大輔等三位公子也成為鼈甲磯貝的得力繼承者。磯貝先生的活動範圍相當廣大，曾加入文化使節團造訪法國、俄羅斯、葡萄牙等，在日本國內外都受到相當高的評價。除此之外也在高中及文化機關擔任講師等，竭力於傳承鼈甲文化。職人說道「現今職人如果只是單純做東西的話總有一天會消失。不單只是製作，還得要有理念以及行動」。

Schooled in the craft by his father Kota-himself an Order of Cultural Merit recipient-Minoru Isogai's talent was recognized by the government of Japan with an Intangible Cultural Asset designation in 2002. Today he is internationally acclaimed for his demonstrations of the craft overseas, while at home he is working to pass down the bekko tradition by lecturing at high schools and cultural facilities throughout Japan, among other activities.

P 74 上
將削得很薄的好幾枚鼈甲疊加在一起。不使用接著劑的「合わせ（壓製合成）」是最困難的。

P74 下
鼈甲工藝品所使用的道具多為職人自己製作的，也會使用天然草木。

P75
以直覺及熟練的技術，專心進行每一個工程。

P76
在最後的刨削工程絕不能用手直接接觸鼈甲。據說如果沾到手的油脂，30年後會變質。

鼈甲磯貝
東京都江東区亀戸 3-3-6　TEL：03-5628-1244

Photo/ 和田京子

江戶毛刷

毛刷為塗抹物品用的道具。如今被指定為江戶毛刷的有經師毛刷、染色毛刷、人形毛刷、漆毛刷等7種。能拿來當作素材的毛有人髮、馬、鹿、山羊、棕櫚等，毛刷師依照不同的用途，以專業的眼光進行挑選。毛刷的精髓就在毛梢，「塗了不會斑斑點點」、「有韌性」的便是優良品。因此，製作毛刷的工程，絕大部分都在梳理毛梢，拉直捲曲以及去除油脂。

Hake paintbrushes are used primarily for the application of delicate watercolors. They may be made of any of a number of materials, including human hair, horsehair, and deer, sheep or goat hair, with the actual selection based on the intended application, and the discerning eye of the brushmaker. The tip is crucial: to be considered an excellent hake brush, it should have sufficient body to allow the ink or watercolor to flow properly from the belly of the brush to the tip, without any excess remaining after the stroke is completed.

EDO HAKE

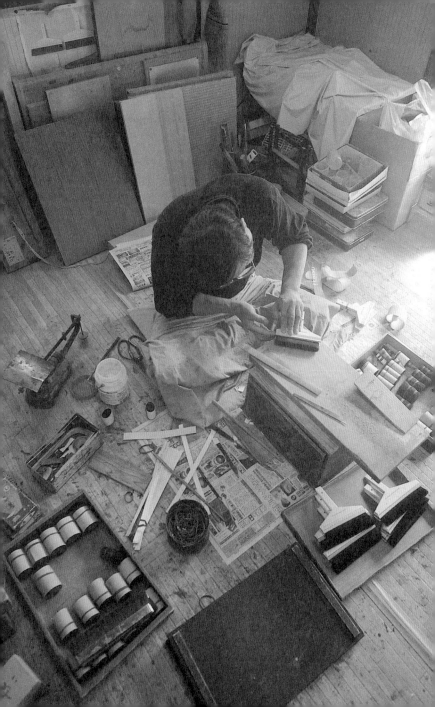

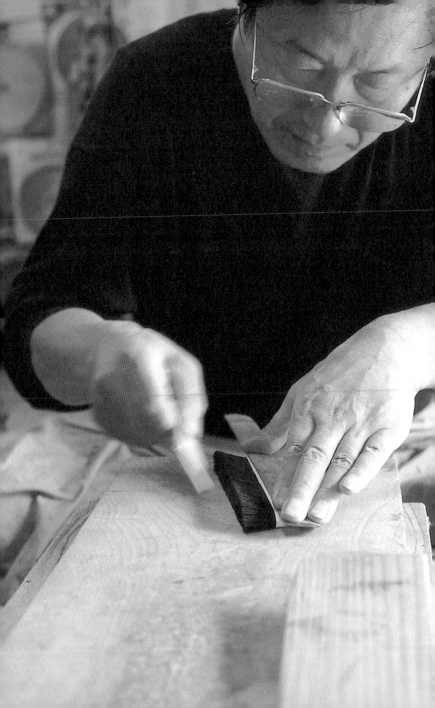

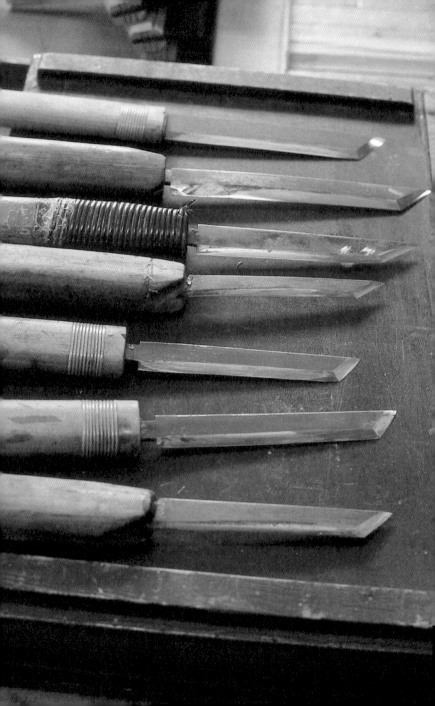

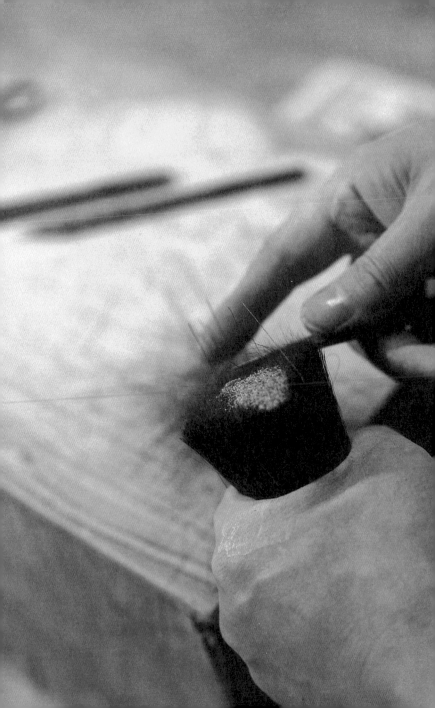

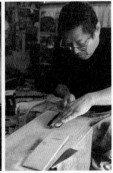

小林刷毛製造所

田中重己 (たなか しげみ)

田中重己為入行40年的老手。國中畢業後便跟隨父親開始製作毛刷。也一邊在高中及大學的夜間部學習化學。現在努力以傳統的工法，並發揮所學的化學知識，製作新的毛刷工藝。

Shigemi Tanaka has been making hake brushes for 40 years, from the time he began learning the trade from his father right after junior high school. He continued on through high school and college, where he studied chemistry. Today, he brings both his scientific knowledge and his mastery of traditional brushmaking methods to bear in creating new hake brushes.

P79
職場就在自家內。基本上都是坐著工作。

P80
為了方便使用，職人仔細地研磨著握柄。

P81
製作毛刷不可或缺的刀剪。用慣的工具上遍布著歷史的痕跡。

P82
製作毛刷最重要也最困難的工程便是「すれとり」。將沒有尖端的毛以及逆毛去除。

小林刷毛製造所

千葉県習志野市藤崎 5-7-5　TEL：0474-72-3431

Photo/ 高橋洋平

東京佛龕

東京佛龕始於江戶時代後期（1840年左右），由江戶佛師安田松慶製做而成。特徵是使用黑檀、紫檀、屋久杉等硬木，並凸顯這些素材的美麗木紋。大致可分為裁木、雕刻、塗漆、組裝等4個工程。為了製作出堅固的成品，每個工程都講求毫無差錯的技術。青嶋先生所製作的東京佛龕曾獲得東京都知事賞等多數獎項。

Butsudan craftsman Shokei Yasuda gave the traditional Buddhist family altar a signature look toward the end of the Edo Period, with techniques and materials unique to what is now the Tokyo area. The Tokyo butsudan is made from ebony, rosewood or Yakusugi cedar, specially crafted to bring out the natural beauty of the wood grain. Precision craftsmanship is a must in each of the many production processes, to ensure that the butsudan is hard and durable enough to be passed on from generation to generation.

TOKYO BUTSUDAN

有限会社青嶋仏壇製作所
青嶋由雄（あおしま よしお）

從小便跟隨父親一起製作佛龕。「職人的工作就是有求必應。如果嫌麻煩的
話不如就不要做了」是青嶋先生一貫的主張。體會到「最重要的是人與人的
關係」，職人在工作之餘，也會處理町內會的出缺席狀況及計畫孩童們的祭
典，在外工作時幾乎是每5分鐘就會有居民來打招呼。出生在這個土地上，
以職人的身份在此生根，並守護著城鎮。這樣的職人身旁總是聚集著人群。

One of the nation's premier butsudan makers, Yoshio Aoshima
mastered the art when he was very small, helping his father create the
altars. He has distinct views on his craft: "I suppose you can call me a
craftsman, but I'm just a man who builds a place of prayer for people, as
they want it built. It's simple work, really, but if I love it. And if I ever
tired of it, I'd give it up." His work in creating Tokyo butsudan has been
recognized with multiple Tokyo Metropolitan Government awards.

有限会社青嶋仏壇製作所
東京都台東区台東 4-21-21　TEL：03-3831-8713
ショールーム：東京都台東区台東 3-27-7

Photo/ 星ひかる

江戶手簪

使用鑷子將薄小的絹布，一片一片接黏在一起而成。穿著和服的女性頭髮上所佩戴的美麗手簪，點綴著四季更替的花草及生物。七五三、振袖等，穿著和服的女性頭髮上所佩戴的美麗手簪，點綴著四季更替的花草及生物。分成表現柔和之美的「丸つまみ」以及表現氣勢之美的「角つまみ」，無論哪種作品都宛如真的花草生物一般。其歷史相當長久，從江戶時代開始持續至今，為日本特有的作法以及表現手法。目前手簪職人只有15人左右。

Tsumami Kanzashi are ornamental hairpins named for the pinching (tsumami) process by which they are created: fine squares of dyed silk are "pinched" with tweezers into the correct shape and placed onto adhesive backing. Most kanzashi adorn the coiffures of kimono-clad girls celebrating the shichi-go-san festival on the occasion of turning three, five or seven years old, and of grown single women in their formal furisode kimonos. Kanzashi handiwork is unique to Japan, with a proud history dating back to the Edo Period. However, only about 15 kanzashi makers remain to ply the craft today.

EDO TSUMAMI KANZASHI

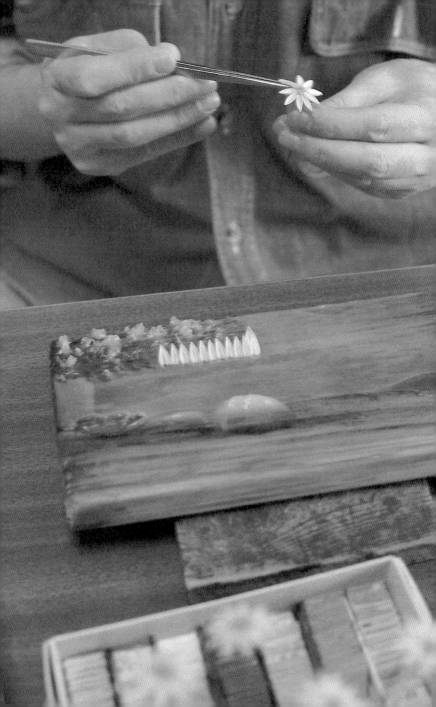

つまみかんざし博物館
石田毅司 (いしだ つよし)

居住於新宿區。從父親手上接下代代相傳的手簪職人之務。到完成為止，全部的工程皆獨自進行，職人認為作品能表現對人的感情這點，是最有意義的。反覆思考並重做新設計，當完成心目中理想的作品時，那種喜悅無與倫比。因目標不只是滿足自己，更希望能滿足大眾，所以目前也在各大百貨公司展示、販賣。

Shinjuku craftsman Tsuyoshi Ishida took over tsumami kanzashi production from his father, and today handles all phases of the process himself. His attachment to the craft is quite emotional: nothing is more rewarding for an artisan than finishing a product that embodies his own passion while also expressing the passion of the wearer. His tsumami kanzashi are displayed and sold at department stores, among other venues.

つまみかんざし博物館
http://www.ask.ne.jp/~kanzasi/

Photo/ 清水真紀子

東京扁額

早期的扁額基本上是寺廟及佛閣的屋頂、鳥居等處所掛的「篆額」。當時是依照畫家的指示，木匠製作木框後，由佛師在上面雕刻，再由塗漆師上漆的一項工程。

到了明治時代，受到歐美文化的影響，洋畫（油畫）的技術傳到日本後，製作扁額不再分工，而是有專門的工房，從頭包辦所有工程。一般認為始於當時的塗漆師——長尾健吉在芝愛宕町所建的小工場。

Originally, gakubuchi were framed pictures created under the direction of the painting artist, with skilled joiners putting together the wooden frame, and busshi -sculptors of Buddhist statues-doing the woodcarving of the image, which was then lacquer finished by nushi artisans. However, studios capable of more unified frame production arose during the Meiji Period, with the introduction of techniques for western-style (yoga) oil painting. The first frame production center is believed to be the small factory built by Kenkichi Nagao at Shiba Atago-cho.

TOKYO GAKUBUCHI

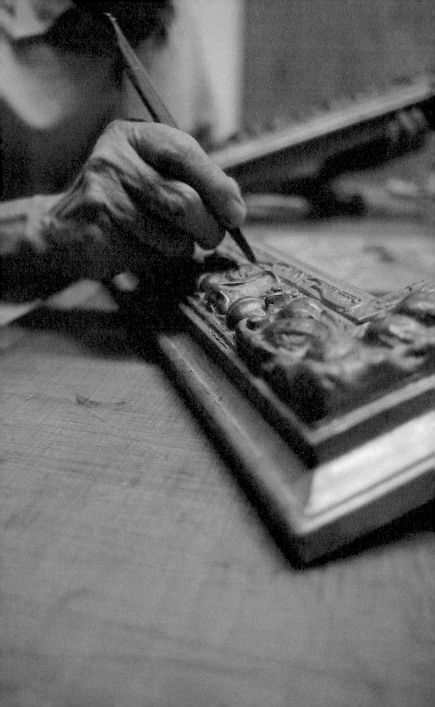

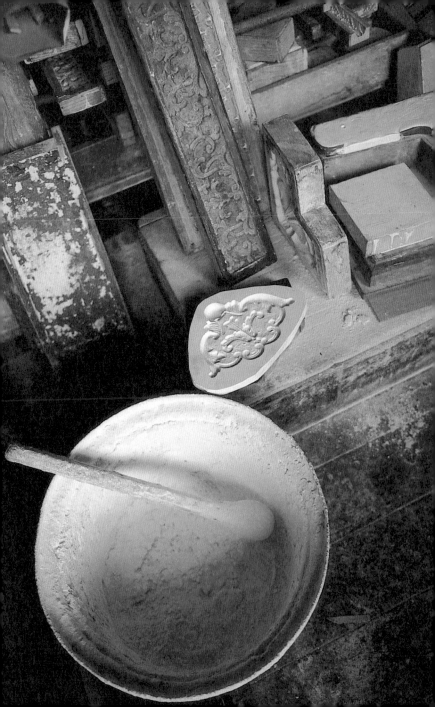

有限会社大江額緑店
大江洋一（おおえ よういち）

距六本木十字路口步行10分鐘，大江緣額店從前就位在六本木通上。大江先生的扁額，特徵就在於渾厚且富有格調，花樣技術也相當出色。大江先生曾充滿驕傲的笑著說「我什麼東西都做得出來呦」。如今雖然現成的扁額成為主流，但在大型美術展開展前，總是會有許多畫家來向大江先生訂製。只要有手工製作的需求，職人精神就不會被澆熄。

The Oe Gakubuchi Frame Shop established its store on Roppongi Dori early in the history of modern frame production. Frames available there now, created by Yoichi Oe, acclaimed for his superb patterning technique, convey a stately dignity, their defining feature. Today the shop principally sells ready-made frames, but whenever a major art exhibition draws near, orders pour in from the exhibiting artists. The craftsman's spirit that informed the first gakubuchi frames remains alive and well in at least one Tokyo location.

有限会社大江額緑店
東京都港区六本木 4 丁目 1-18
TEL：03-3403-3026

Photo/ 篝 美也子

江戶象牙

奈良時代傳到日本的象牙製品，在江戶時代作成墜飾、髮梳等日常品廣為普及。

如今，最常被使用在印鑑上，這些象牙印鑑的手感，也顯示了象牙製實用品的優秀。目前從南非、辛巴威、波札那、納米比亞等四國進口象牙。這些國家皆確保了象隻一定的數目，並遵循華盛頓條約出口象牙。

Ivory work, or zoge, started in Japan during the Nara Period, reaching the height of its popularity during the Edo Period, when ivory combs and detailed miniature sculptures known as netsuke became everyday artifacts. Today, demand is greatest for use in personal seals, although supply is limited, since Japan has implemented an ivory control regime under the terms of the Washington Treaty restricting global trade in endangered species.

EDO ZOGE

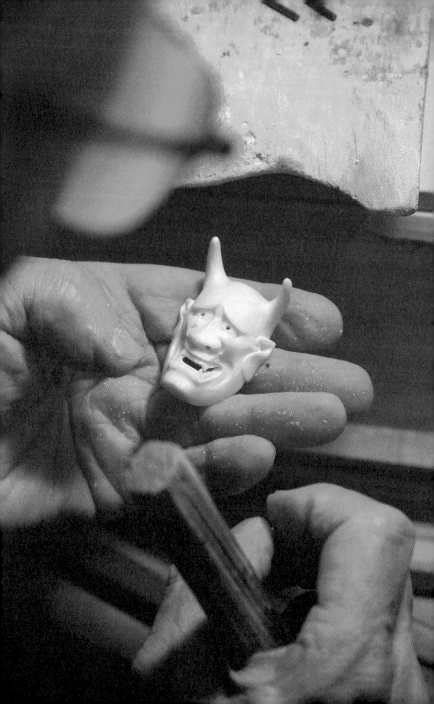

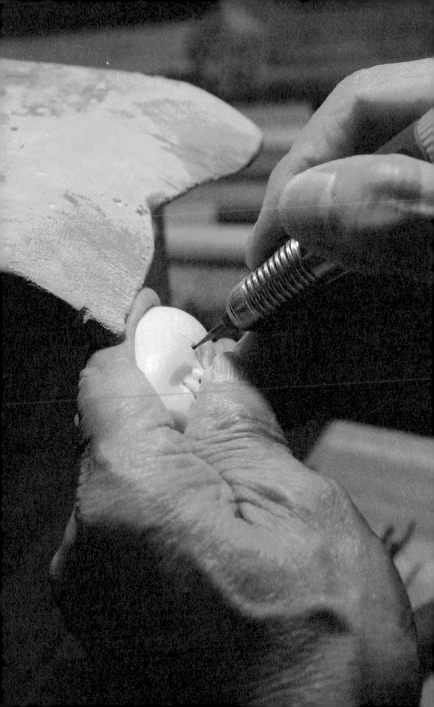

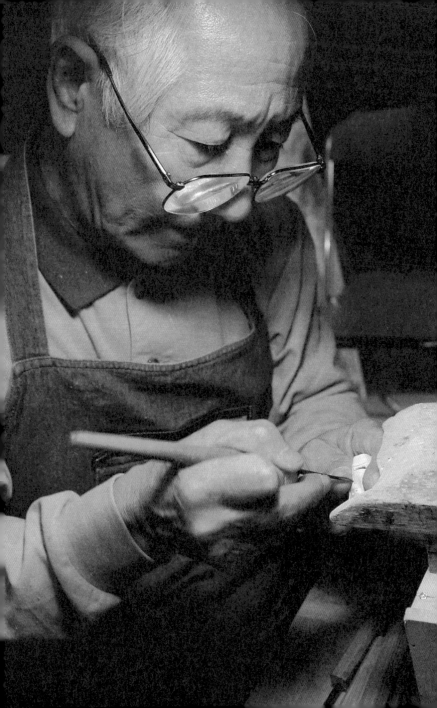

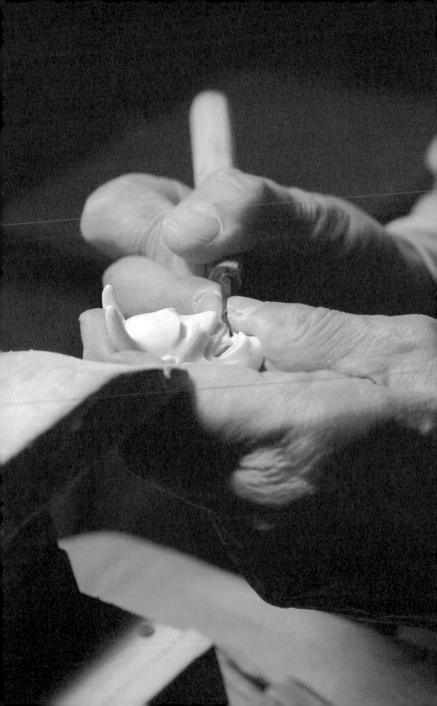

桜井牙彫製作所

桜井 実 (さくらい みのる)

出生於昭和10年。日本象牙美術工藝協會連合會會長、東京象牙美術館工藝協同協會理事長。15歲師事父親廣晴後，50年來身為象牙職人持續雕刻著傳統工藝。兄弟皆為象牙職人的職人一家，桜井先生自己至今也培育了4名繼承者。現在除了從事職人的工作，也擔任協會的幹部，致力於推動象牙進口的穩定化。「象牙製品不僅是實用品，也有工藝品的價值。它能將一度死去的象，化為作品永遠留存下來」。

Minoru Sakurai mastered ivory work as a boy, under the tutelage of his father Hiroharu. In the ensuing 50 plus years, he has carved a niche for himself as an acclaimed ivory craftsman, a member of a prolific family of ivory workers. Sakurai is presently a trade association leader, devoted to maintaining a steady and sustainable supply of ivory to sustain the craft. "Once an elephant dies, it is incumbent on craftsmen to make sure it lives on in artistry," he says, touching on his greatest passion.

P97
雖然也有人對於象牙有非法狩獵的印象，但江戶象牙所使用的是取自於自然死亡的象、或是為了維持生態而在政府的管制之下所取得的象牙。

桜井牙彫製作所
東京都板橋区東新町 1-51-2　TEL：03-3955-1805

Photo/ 吉原克則

江戸細木器

細木器是指不使用釘子，只用板、棒接合，外表看不出接縫的抽屜、鏡台、置物桶等家具的總稱。細木器大致可以分成擁有華麗外表的「京細木器」以及講求純樸的「江戶細木器」。

特別是江戶細木器善用素材的紋路，烘托出人們所追求的「自然風」，令人目不暇給。

Sashimono is a type of furniture constructed only with (mortise and tenon) joinery, but no nails and screws. The interlocking is entirely internal, so that it cannot be seen on any outer surface of a finished piece. Drawers, mirror stands, trash receptacles and other interior items for Japanese rooms are created in the sashimono style. In Edo sashimono, different kinds of trees are used, carefully selected for their distinguishing characteristics, with the focus on maintaining the natural design of the wood in the finished piece. Thus, the eye-catching beauty is provided by nature and channeled though the craftsman.

EDO SASHIMONO

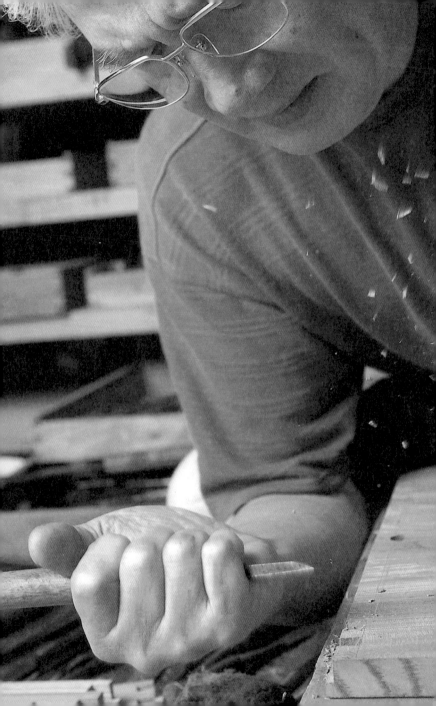

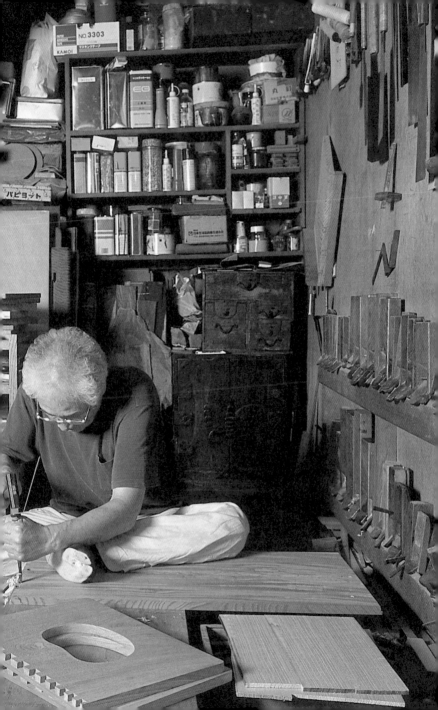

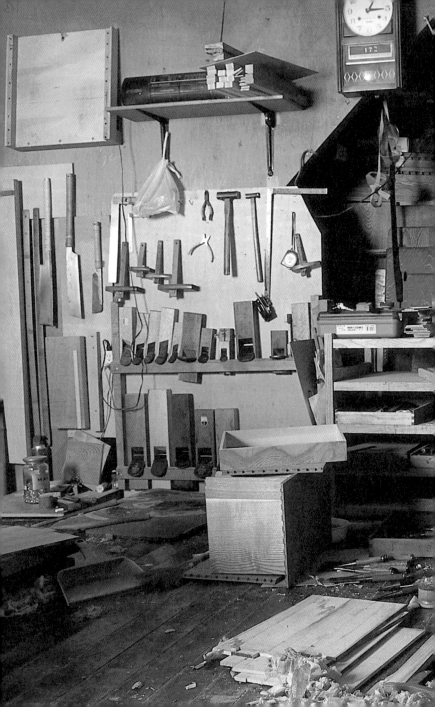

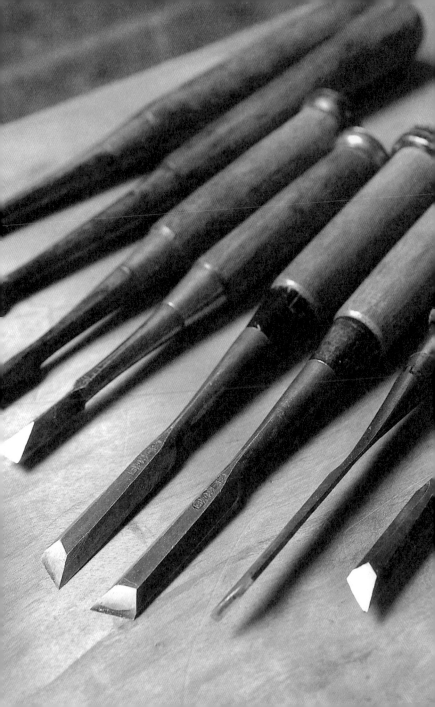

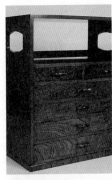

大渕木芸

大渕浩吉（おおぶち こうきち）

出生於東京，為大渕浩藏的長子。中學畢業後師事父親成為第二代。因煩惱保管材料的場所而搬遷的倉庫內，有各式各樣的木材堆擠於其中。「遇到好的原木就忍不住入手了。給家人帶來不少麻煩，實在很感謝他們」。第三代由長男光高繼承。「雖然他入行5年了，現在才要開始呢」浩吉先生如此嚴厲地說著，但表情滿是喜悅。

Kokichi Obuchi was born in Tokyo, the eldest son of a sashimono artist. After graduating junior high school, he mastered the craft under his father's tutelage, eventually taking over the family furniture-making business. Always on the lookout for superior material, his workplace is crammed with mulberry, cypress and other wood waiting to be incorporated into traditional Japanese furniture. His eldest son Mitsutaka is being groomed to carry on the family tradition to the third generation.

P103
到了工作室便換了一個神情。以認真的眼神，將生命注入木材中。

P104-105
稱為「榫卯」，為接合木板的加工方式。技術講究到外表完全看不出接合處，是可看出職人功力之處。

P106
各式各樣的鑿子。平鑿、圓鼻鑿等，依照加工的地方使用不同的鑿子。

大渕木芸
埼玉県川口市芝 4060-6　TEL：048-265-9106

Photo/ 丸山英樹

江戶簾

簾子非常的實用。從晃動的簾子也能觀察風向。簡約的設計，突顯出機能性及藝術性，堪稱是日本人的智慧。江戶簾的製作過程為活用竹、荻、蒲、蘆葦等天然素材的特性，並相當講究色澤、粗細、割法等，製程從古至今未曾改變。

Sudare, or matchstick blinds, are made of stems of bamboo, bush clover (hagi), birch (kaba), ditch reed (yoshi) and other natural materials, bound or plaited together in their natural state with cord. Spaces are left between them that allow air to pass through easily, while blocking out the light. The spare design of the sudare blinds is the embodiment of Japanese wisdom, highlighting functionality and artistry.

EDO SUDARE

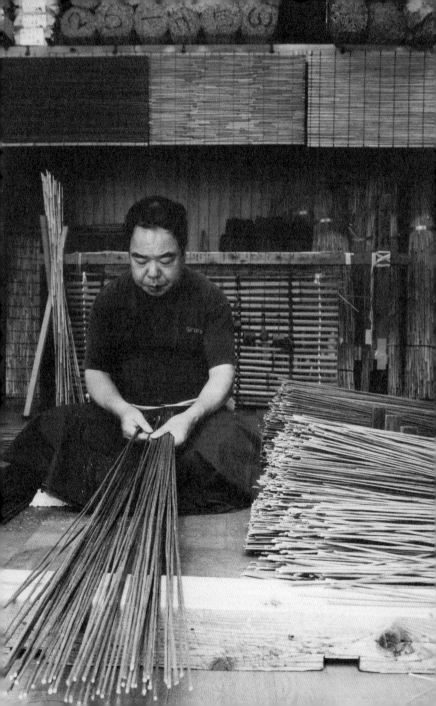

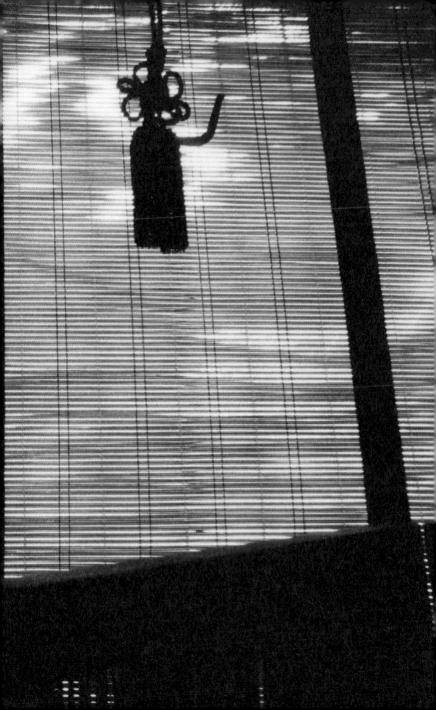

田中製簾所
田中耕太朗 (たなか こうたろう)

第四代田中義弘、第五代田中耕太朗皆為東京都傳統工藝士，田中製簾所的
職人們以父子兩代為中心運轉著。為明治初期沿續至今的江戶簾老店。材料
與工具堆積的工作場中，職人們安靜地工作著。第五代田中耕太朗先生個性
有禮又溫和。

Tokyo's premiere Sudare producer is the Tanaka Sudare Workshop,
where the forth-generation proprietor, Yoshihiro Tanaka, and his son
and heir, Kotaro Tanaka, work silently among others. The workshop
has continued in business since the beginning of the Meiji period. Both
Yoshihiro and Kotaro Tanaka are Tokyo's premiere certified traditional
craftsmen, who are eager in their work and have courteous and
warmhearted personalities.

田中製簾所
東京都台東区千束 1-18-6 TEL：03-3873-4653

Photo/ 斉藤沙綾香

江戶印花布

印花布始於3000年前的印度。於室町時代至桃山時代，漂洋過海傳到日本。富有異國風情的染布，刻畫著從印度橫跨絲路到中國、再抵達日本的這一段風華歷史中，參與其中的人們的各種意念。將木棉染上五彩繽紛的模樣，色彩亮麗、充滿異國風情的印花布。不只拘泥於運用在和服上，也可變身成絲巾等各種飾品。

Sarasa dying originated in India, more than 3,000 years ago. It was introduced to Japan during the Muromachi Period, and spread further during the Momoyama Period. Sarasa dyed cotton is a riot of five colors that create exuberant and exotic patterns, reminiscent of batiks. The technique is widely employed for kimonos, but sarasa is also used to make colorful handkerchiefs, scarves and other accessories.

EDO SARASA

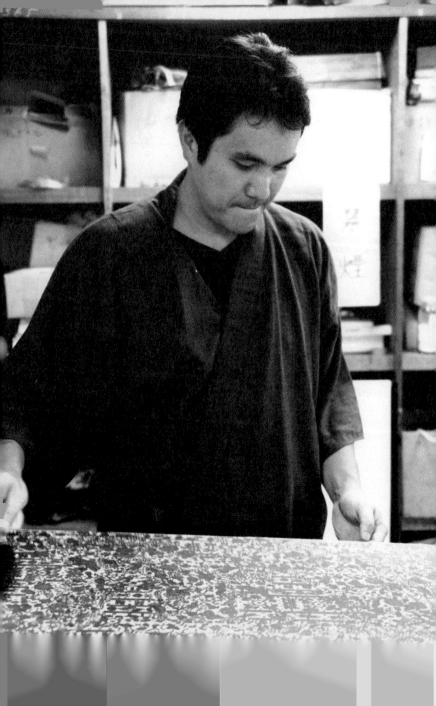

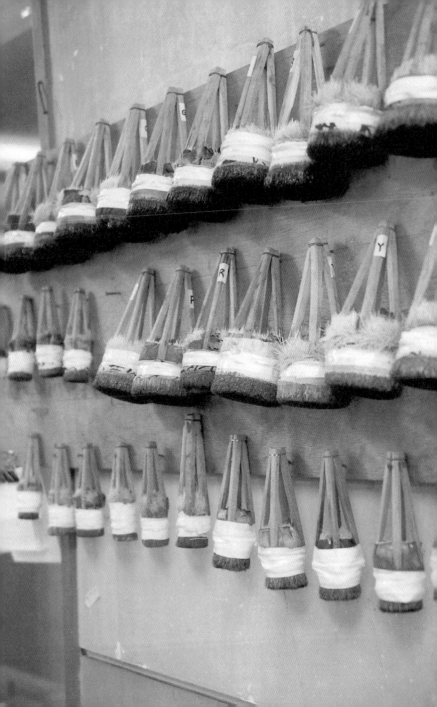

染の里　二葉苑

小林元文（こばやし もとぶみ）

目前東京都內只有三間工房在製作江戶印花布，其中一間便是「染めの里 二葉苑」。「江戶印花布還有很多未知之處。想要將染布的美麗及趣味繼續 傳承下去」第四代的小林元文如此說道。

Only three dye houses in Tokyo are still active in the sarasa silk-dyeing trade. One is the Some no Sato Futaba-en, run by fourth-generation kimono maker Motobumi Kobayashi. After all his time in the business, he remains stricken by what he calls the "incalculable charm" of sarasa. For Kobayashi, sharing his craft is his mission. "I want to pass the beauty and fascination of silk dyeing on into the future."

染の里　二葉苑

東京都新宿区上落合 2-3-2　　TEL：03-3368-8133

Photo/ 高木佳代

東京本染浴衣

浴衣原本為入浴時穿在身上的衣物，其歷史可追溯至平安時代。

江戶時代，因大眾浴池的普及，在澡堂泡澡成為一種習慣。並流行泡完澡後穿上印有中型花紋的木棉單衣。直到明治時代浴衣才開始在廟會、祭典、煙火大會等活動時當做外出服穿著。

昭和30～40年代，浴衣與手帕的需求到了高峰。如今，手帕成為主力商品。旭染工每年約染製10萬反（1反＝11條）手帕。

The yukata began to take shape in the Heian Period, when a wide-sleeved cotton kimono was worn to the bath. When public baths became common during the Edo Period, the modern unlined yukata-style kimono came in to vogue. The custom of wearing the yukata to festivals and events, or for casual strolls on summer evenings, took hold later, during the Meiji Period.

TOKYO HONZOME YUKATA

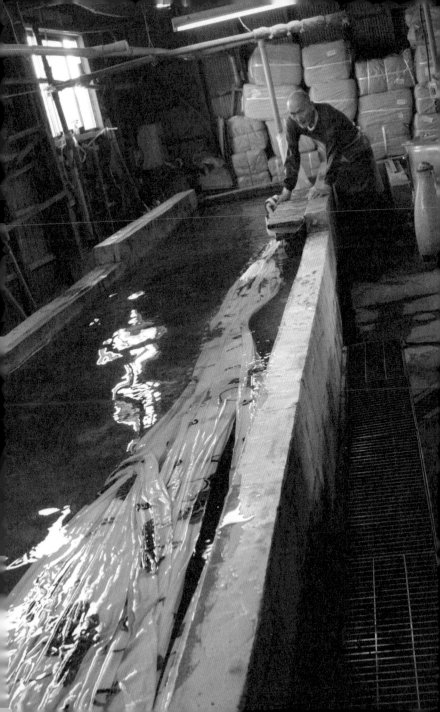

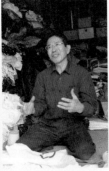

旭染工株式会社　阿部晴吉（あべ はるよし）

昭和21年出生，今58歲。因父親為工場的負責人，18歲便開始從事東京本染浴衣的工作。40歲時接下工場，目前也擔任關東注染工業協同協會的代表理事長。旭染工的強項在於「老手職人的技術」。而阿部先生的信念是「能因應常客的各種需求，將工作做到盡善盡美」。現在於日本橋的布料店戶田屋、丸久商店等販賣中。

When Haruyoshi Abe was born in 1946, his father was running the kimono factory. Harukichi began making honzome yukata at age 18, and was in charge himself by around 40. Today he sits on the board of directors at the Kanto Dyeing & Weaving Industry Association. Speaking about his own facilities at Asahi Senko, he mentions "the technical expertise of our veteran craftsman" as the company's greatest advantage.

旭染工株式会社

東京都足立区花畑 2-14-6　TEL：03-3883-0014

Photo/ 肥田木智子

東京本染浴衣

浴衣始於平安時代初期，沐浴時穿著於身上的單衣「浴帷子」。江戶時代中期，則是指泡完澡後穿上的和服，到了明治時代，才像現在一樣成為夏天外出服。

東京本染浴衣乃是將木綿充份地染上以藍色為基調的染料，是一款質感超群的逸品。舒爽的觸感，以及簡單又蕩漾著清涼感的美麗染布，與現今流行的印花浴衣劃出了區別。

The Tokyo Honzome yukata is created with indigo applied to cotton fiber in the traditional Japanese art of pattern dyeing. The dye is allowed to seep completely through the cloth, creating an exuberant interplay between color and texture, and a finished product of understated elegance and timeless beauty. Its soft touch and the chic, cool feel the dye gives off sets a true Tokyo honzome apart from the fleeting fashion of the print yukata.

TOKYO HONZOME YUKATA

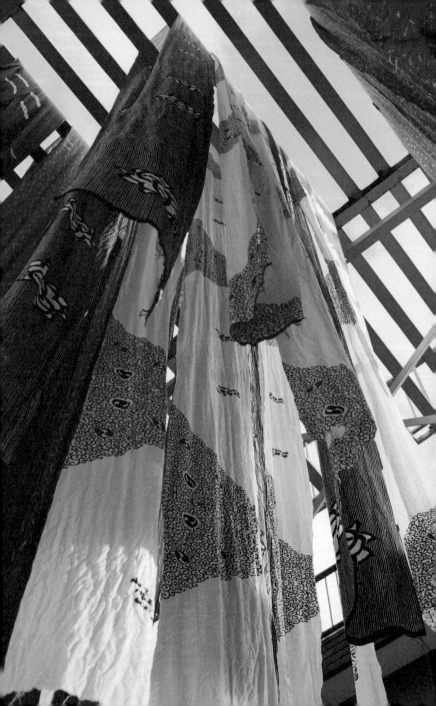

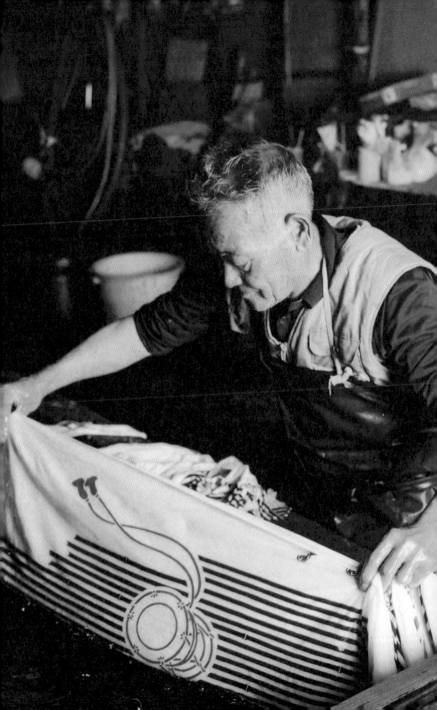

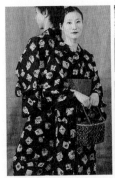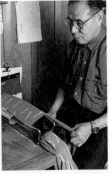

有限会社村井染工場
村井米扶（むらい よねすけ）

昭和11年2月26日，二二六事件當天，出生於東京。12歲開始參與家業，昭和32年5月，成為第二代繼承了工場。平成2年2月得到東京都傳統工藝士認定。現在多為製造四季皆可使用的手帕，客源來自企業、團體、說書藝人、演歌歌手等，相當廣泛，據說也相當受到已故演歌歌手美空雲雀的喜愛。精心、認真製作的職人，今後將與第三代的光壽先生一同將浴衣文化傳承下去。

Yonesuke Murai was born on the day 1,400 junior military officers launched an infamous uprising against the Japanese government, February 26, 1936. By the age of 12 he was working and learning the family business, which he eventually took over from his father in May 1957. Murai continues creating yukata with the skill, patience and painstaking attention to detail that define the true craftsman. Together with his son and heir Mitsutoshi, he is working to bring the beauty of traditional Japanese fabrics and the values of yukata culture to the wider world.

有限会社村井染工場
東京都江戸川区一之江 6-17-27　TEL：03-3651-3108

Photo/ 佐藤正崇

江戶和竿

江戶和竿為將天然素材的竹子上漆製成的可接可卸的釣竿。17世紀後半，泰地屋東作於下谷稻町的廣德寺前開業為其起源。

江戶和竿的外型美觀，不單只是釣具，還是相當別出心裁的精品，有些甚至將龜甲及象牙點綴在竿尾塞及捲線器上。從竿子的狀態到最後修飾，都可以配合自己的喜好，製作出世界上獨一無二、最好的釣竿。

The Edo wazao is a special bamboo rod, made of whole, natural unsplit bamboo and lacquer finished, used as a traditional fishing rod. Tosaku Taichiya commercialized it in the late 17th century, developing what was a perfectly personalized product, from selection of the bamboo to the final finish. Because each wazao was built to individual taste and specification, no two ever created were exactly the same.

EDO WAZAO

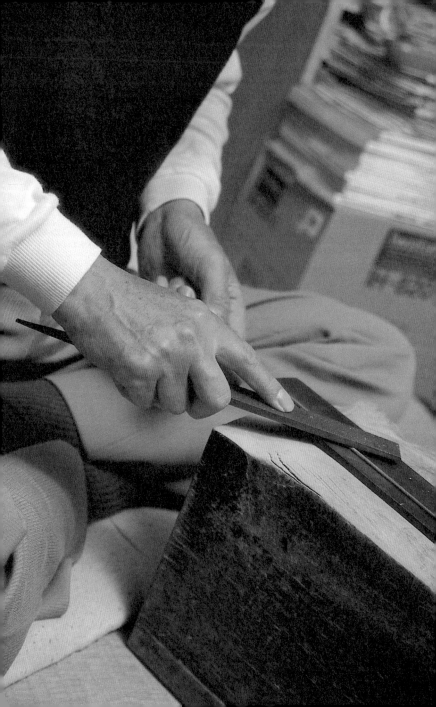

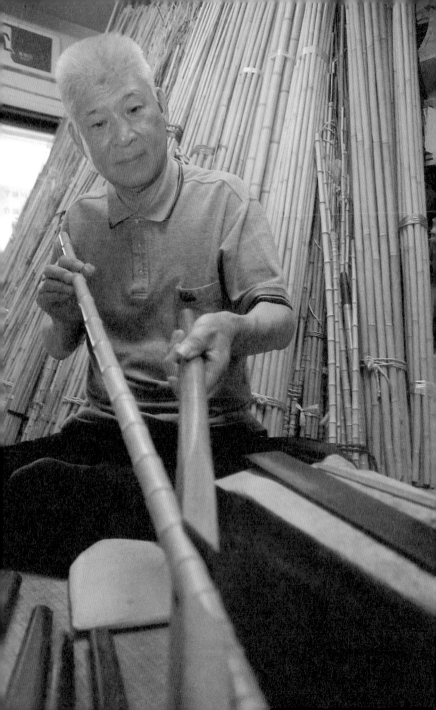

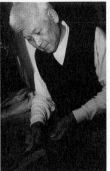

竿忠

中根喜三郎 （なかね きさぶろう）

竿忠的第五世，也是第四代傳人，並兼任江戶和竿協同協會理事長。竿忠（名號）代代只傳給長子，所以身為中根家三男的喜三郎，原先沒有意願成為製竿師。在東京大空襲失去雙親及兩位兄長，每天過著恍惚的日子，在父親的友人三遊亭金馬勸言下，決心成為製竿師。中根先生說道「自己都無法滿意的釣竿，是絕對不會交給客人的」。這就是所謂的職人。

As the great-grandson of the famous craftsman Saochu, Kisaburo Nakane is a fourth generation Edo wazao maker. He also serves as director of the Edo Wazao Cooperative Association. Originally, the family business was to be passed on to his brother, the eldest son, but the Nakane home was destroyed in the air raids of WWII, and Kisaburo lost his two older brothers. He then committed himself to becoming an accomplished wazao craftsman, with a drive and a faith in his art that has never diminished. "I could never allow myself to make wazao that I don't entirely believe in, much less deliver anything less than the very best to the customer."

P130
將乾燥後的竹子在火盆上加熱，將彎曲處拉直。此時，使用稱為「矯め木」的工具，拉伸竹子，修正複雜的曲度。這便是將靈魂注入竹子的瞬間。

竿忠

東京都荒川区南千住 5-11-14　TEL：03-3803-1877

Photo/ 小林修一

江戶著裝人偶

江戶著裝人偶，最早始於源氏物語時代，直至德川綱吉的時代成為平民的玩物而廣為流行。人偶的種類有身穿華麗和服的藝伎人偶、娃娃人偶、懷中人偶等。其中以歌舞伎演員「佐野川市松」為原型的人偶大獲好評，為現在市松人偶的由來。取用天然素材，並經由上百種傳統作業製成的人偶，優雅又有格調，絕對是量產商品所無法比擬的。

Edo costume dolls (isho ningyo) arose from a tradition dating back to the days of the Genji Monogatari. Costume dolls had become popular during the reign of the Shogun Tsunayoshi Tokugawa in the late 17th century. In addition to baby dolls, the figurines represented courtesans and geisha dressed in the fashionable kimono of their time. These Japanese fashion dolls are made using techniques refined over the generations, for a timeless elegance that their mass-manufactured counterparts cannot hope to reproduce.

EDO ISHOGININGYO

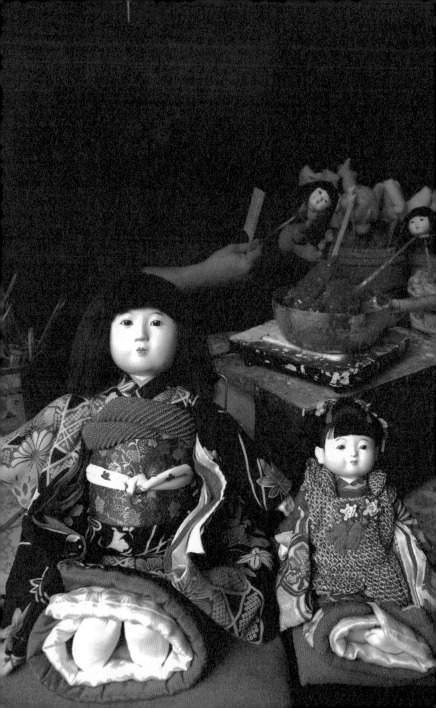

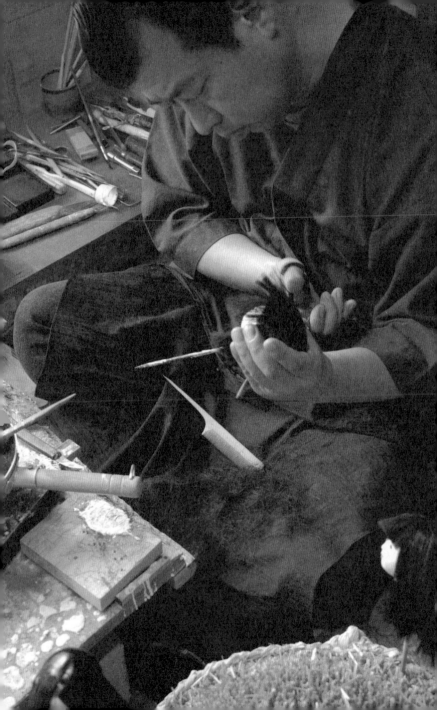

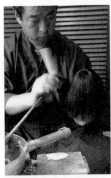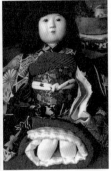

市松人形工房 松菊
菊地之夫（きくち ゆきお）
昭和32年出生於葛飾區。師事父親菊池貞治。此後，全心專注於製作人偶。
歷經多重修行，不只市川人偶，也學習了五月人偶、雛人偶等的製作方法。
現在則致力於磨練自身技藝，以傳統技法製作出最優質的人偶，並盡心創作
出自己也滿意的作品。

Yukio Kikuchi was born in Tokyo's Katsushika Ward in 1957. From the
time he began studying under his father Sadakichi, his life has been
devoted to doll-making. During a long formal apprenticeship, he
mastered both the Ichimatsu play dolls that have captivated generations
of Japanese children, and the exquisitely crafted hina ningyo
representing the Imperial court. Kikuchi continues honing his skills,
hoping to please his most demanding critic-himself.

市松人形工房 松菊
東京都葛飾区青戸 3-41-3　TEL：03-3602-1452
http://www.ichimatsu.com/

Photo/ 大竹邦昭

江戶雕花玻璃

江戶雕花玻璃普及於天保年間的江戶，明治時代時，因受到西洋餐具以及日用品進口的刺激，而變得更為普遍。爾後便發展為墨田及江東地區的地方產業。主要製品為碗、盤子、玻璃杯、酒杯等。製作方法為在玻璃上畫出原型後，以圓盤狀的磨石削磨，加上設計，磨平後完成。有蜘蛛巢、龜甲、斜紋、編織紋、菊花等圖樣。

The exquisite cut glass craft known as kiriko gained popularity during the Edo Period, and developed as a local industry in the Sumida River area of Edo. Expert glassblowers and glasscutters create the ornate kiriko glassware, including bowls, dishes, glasses, and sake cups. After the glass is blown into a paper-thin, two-layer structure, the pattern design is cut into the glass using different kinds of whetstones, and the kiriko piece is then polished to a finish.

EDO KIRIKO

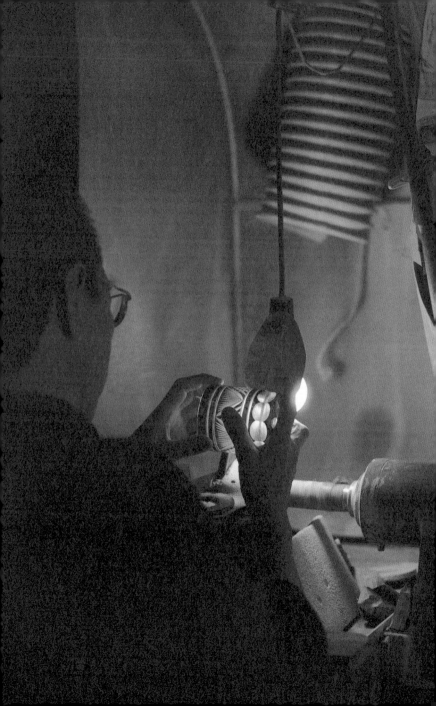

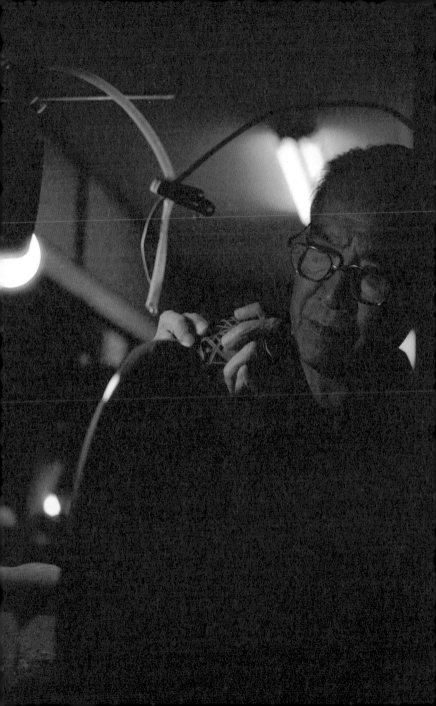

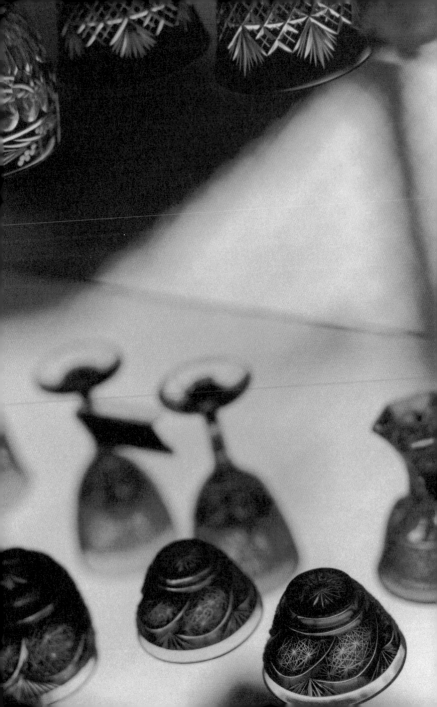

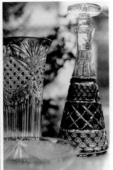

有限会社根本硝子工芸

根本幸雄 (ねもと ゆきお)

根本先生得過許多獎項，為玻璃工藝的代表作家之一。經常嘗試新的製作方法。為了在戰後生存而入了此行。兒子達也先生，在年少時為了養家，也開始製作玻璃工藝，領先引進雕刻的技術，擁有日本屈指可數的手藝。並擅長繪畫、藝術書法等。其工作場上，有著江戶平民之間所傳承下來的環境，以及其氣息。

Yukio Nemoto is virtually synonymous with Edo kiriko, having won numerous awards for his work in the glass medium. His son Tatsuya quickly mastered and incorporated glass sculpture techniques into his own kiriko work, making him one of the most technically gifted craftsmen in Japan. The tradition of superior kiriko craftsmanship continues unbroken to Nemoto's grandchild, blessed with the same sense of artistry.

有限会社根本硝子工芸

東京都江東区亀戸 8-9-4　TEL：03-3682-2757

http://www.fides.dti.ne.jp/~n-kiriko

Photo/ 高橋 稔

江戶貼畫毽子板

在布中填入棉花，做出各種立體花樣的「貼畫」技巧，於江戶初期開始被運用在毽子板上。到了江戶後期，描繪著歌舞伎演員舞台裝的貼畫毽子板誕生，並博得好評。江戶平民文化創造出的工藝品——貼畫毽子板，隨著歌舞伎的發展一同發達，傳統的技法仍繼續傳承到今日。

在女孩子第一次過新年時贈送毽子板的習俗，自古以來帶有消災解厄的意義。

There is a popular Japanese game -played for over 500 years- which resembles badminton but uses no net. It features a rectangular wood paddle (battledore), known as a hagoita, decorated with various images, sometimes executed in relief. At the beginning of the Edo Period, these patterns became more elaborate, with artisans creating intricate designs on the back of the paddles using quilted silk in a way that suggested three-dimensional figures. These included ukiyoe caricatures of popular kabuki actors, as the battledore became a reflection of Edo mass culture. Traditional Edo oshiehagoita handicraft remains in demand today. Just as they did in the Edo Period, parents give their little girls the decorative paddles at the New Year to ward off evil spirits for the entire year.

EDO OSHIE HAGOITA

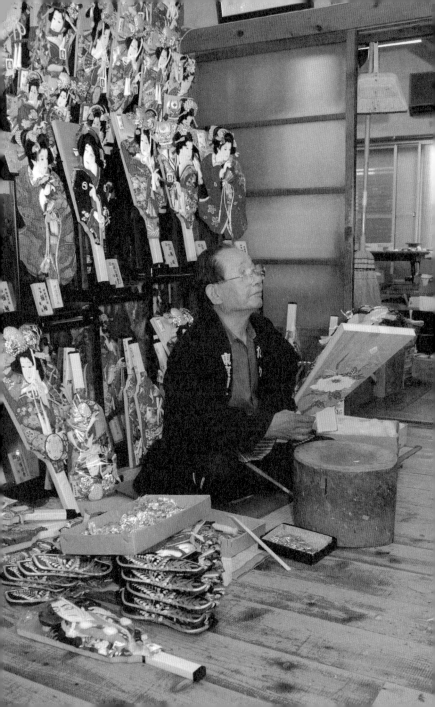

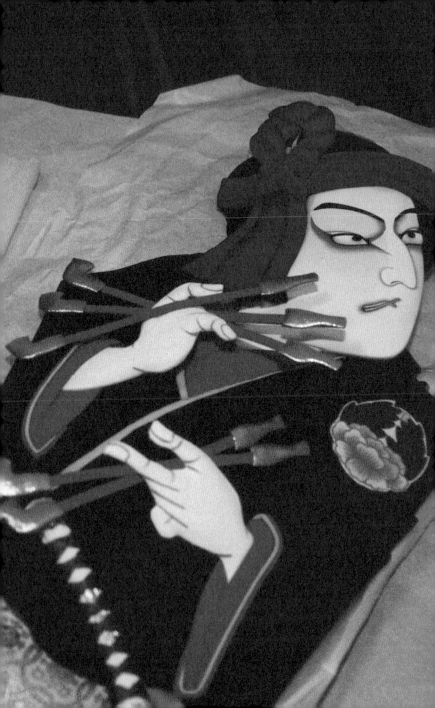

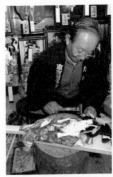

南川人形店

南川行男（みなみかわ ゆきお）

昭和4年，出生於墨田區。東京歲之市毽子板商協會長。昭和20年開始從事製作毽子板，已是入行近60年的資深老手。以製作每年12月17日至19日舉行的淺草毽子板市集中所販賣的毽子板為主。從裝飾在工作室的大小毽子板中，挑出了一款男用的毽子板並笑著說「很美吧？」。表情與製作毽子板時完全不同，相當的溫柔。

Yukio Minamikawa was born in Sumida Ward, Tokyo in 1929. He has been making hagoita for 60 years, ever since the end of the war. Although he produces a wide variety of the decorative paddles, his main focus is the lavishly decorated hagoita sold at the Asakusa Hagoita Fair, in the hope of an auspicious start to the New Year, from December 17 to 19 every year. Mr. Minamikawa is head of the Tokyo Sainoichi Hagoita Association.

南川人形店

東京都葛飾区高砂 3-7-11　TEL：03-3657-3975

Photo/ 細井由紀

江戶甲冑

江戶甲冑為裝飾甲冑師以代代繼承傳統技術及技法，手工製作的工藝品。現在，則以被指定為國寶與重要文化財的古甲冑為模型，利用金工、漆工、編織絲帶、染色、皮革等技術製作而成。

將歷史上名高望重的武將們所身穿的甲冑忠實呈現的技術極為精湛。其精緻與巧妙，確立了獨一無二的世界。為高價值的美術工藝品。

Edo armor, or katchu, consists of elaborate festival garments and ornaments handmade by armor artisans. These are faithful reproductions of the armor worn by famous warlords in feudal times: individual, idiosyncratic, sometimes flashy statements of military class status. Today the unique armor creations are highly regarded works of art.

EDO KACCHU

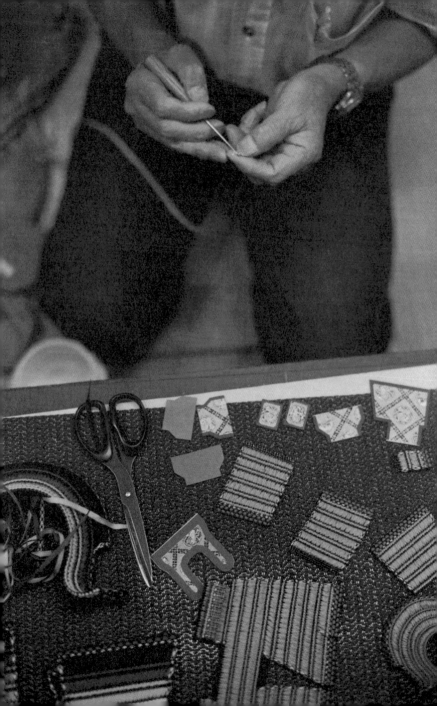

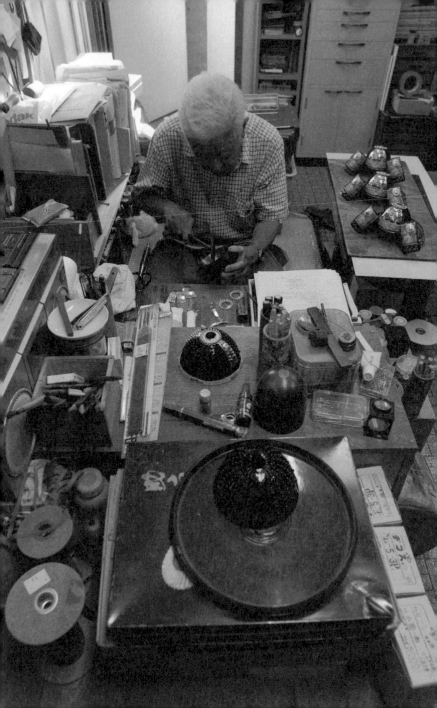

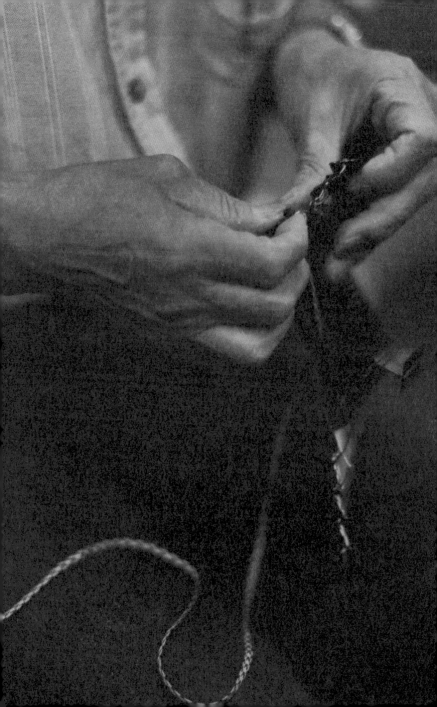

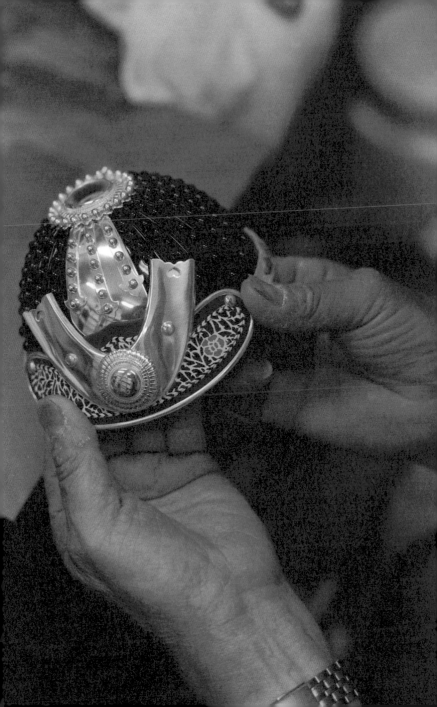

加藤鞆美（かとう ともみ）

初代名匠加藤一冑的次男。將全日本的神社、佛寺中所留存的奉納鎧甲與頭盔忠實再現，擁有當代數一數二的技術，得到很高的評價。職人精通各個時代的甲冑，並以江戶人的腔調述說著，令聽者相當入迷。他的講究之物，是自己從昭和29年開始愛用至今的牛仔褲。腰帶為第三條。當時的鐵製圓形兩孔皮帶鈕環一直使用至今。「每次過機場的安檢時都會被攔下來」如此爽快地說道，是位相當時髦的職人。

Tomomi Kato is one of the nation's leading artisans, specializing in stunning recreations of feudal armor and helmets, as well as offertories for shrines and temples. He is consumed with his work, having now become quite an expert on the history of armor, and is often holding forth on the subject whenever he's not actually creating the suits of armor themselves. Kato is a captivating speaker, as much for his Edokko (native Tokyo) style as for the fascinating subject matter.

東京都文京区向丘二丁目 26-9　TEL：03-3823-4354

Photo/ 高橋 稔

江戶甲胄

從前，甲胄為頭盔、鎧甲等戰爭時所用的武具。江戶時代中期以後，除了原來的使用目的以外，也成為節慶裝飾品。

在日本，端午節為祈禱男孩子能堅強剛毅地長大的傳統節慶。當時會將人氣武將的冑甲以同樣的材料等比例縮小再現，或是做成武將人偶來裝飾。

如今則是流行將鎧甲、頭盔、弓、大刀、草笠形盔、旗幟、篝火等分開擺飾。

Yoroi and kabuto-the famous suits of feudal armor and samurai helmets-were of course the accoutrements of war. However, from the middle of the Edo Period onwards, families with boys have been displaying warrior dolls decked out in miniaturized versions of the armor and helmets. It is part of the Boy's Festival celebration, when parents encourage their young ones to grow strong and brave. Armor was originally produced and worn in sets, but today feudal armor, feudal helmets and bows are often displayed separately.

EDO KACCHU

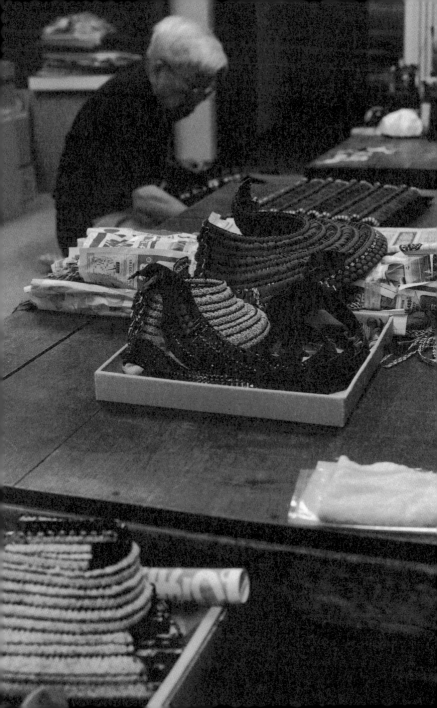

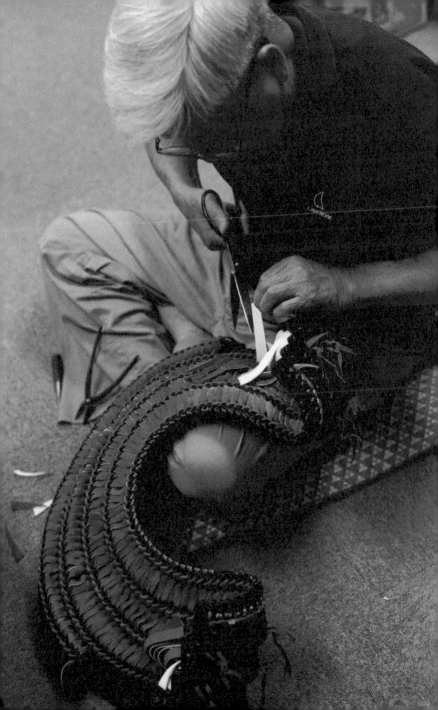

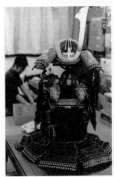

加藤一冑工房
加藤 博 （かとう ひろし）

加藤一家包含親族皆為甲冑師世家。據說上一代的一冑先生，為了研究甲冑，投入自己所有的財產，帶著繪師跨足全日本進行研究。承襲雅號成為當代一冑的博先生，對於研究甲冑毫無旁念。作業範圍從製作縮小版的裝飾用甲冑，到復元真品。另外，在製作舞台及電視道具用的甲冑時，則需考慮到可方便動作。拍攝照片海報時，則改成攝影用的造型等。現代的甲冑師必須要配合顧客的期望臨機應變。

The Kato name is synonymous with armor artistry in Japan. As head of an extended family of prolific armor artisans, Hiroshi Kato has adopted the nom de plume Itchu, reflecting his status as a true artist in armor. He spares no expense traversing the nation with a painter in tow, studying and acquiring original suits of feudal armor, which he painstakingly reproduces in miniature for display purposes. Meanwhile, his full-size creations are in demand from a wide variety of clients, including theaters and television studios.

加藤一冑工房
東京都文京区本郷 6-2-7 香川ビル　TEL：03-3811-5042

Photo/ 高橋 稔

東京藤編工藝

藤為日本沒有的棕櫚科熱帶植物。因耐熱與耐溼氣的特性，藤編工藝除有美術品的價值以外，也具有相當優秀的實用性。將各種特徵及粗細的藤條一一折彎、纏繞，職人的技術創造出藤編工藝品的柔性之美。

雖然傳統工藝給人一種古往今來，一成不變的印象。但小峰ラタン製造的藤編工藝，特徵就在於能率先預測出人們需要的實用性。

Wicker is made from rattan, a special climbing palm that only grows in tropical regions outside Japan. Because it is strong against heat and humidity, there is brisk demand for woven wicker as furniture, among many other practical applications. However, wickerwork handicraft from true masters is also valued as art.

TOKYO TOKOGEI

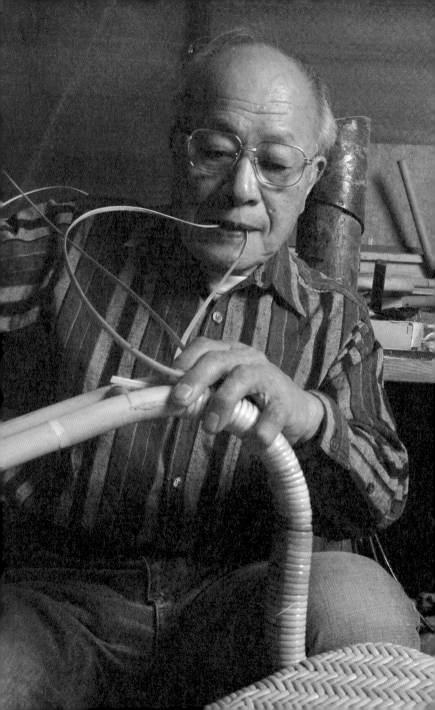

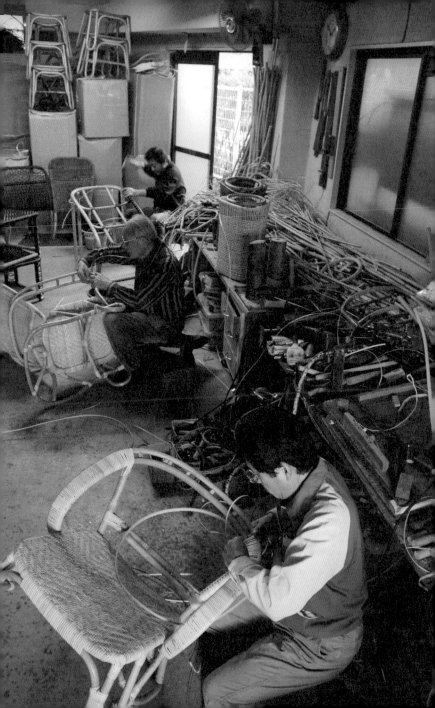

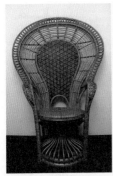
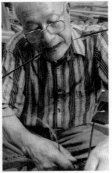

小峰ラタン株式会社
小峰 尚（おみね しょう）

昭和7年出生於淺草。東京都傳統工藝士。13歲時因戰爭而疏散至長野，並在當地與藤職人的叔父學習藤編工藝。於第一屆、第二屆藤編工藝名品展獲得東京都知事賞。平成3年，獲得黃綬褒章。每個月到日本各地的會場，直接將藤編工藝的魅力傳達給使用者。「想要配合使用者來製作。希望能以實用的製品，幫助老年人及行動不便的人」。職人做的每個工藝品，都充滿了如此的心意。

One of Tokyo's premiere certified traditional craftsmen, Sho Omine was born in Asakusa, Tokyo, in 1932. During the war he was evacuated to Nagano to escape the air raids, a quirk of fate that led him to his craft. Mastering wickerwork under the tutelage of his uncle, Omine went on to win numerous awards for his wicker creations. Today he travels the nation with the wicker items, attracting users and aficionados at an array of exhibitions.

小峰ラタン株式会社
東京都墨田区押上 2-10-15　TEL：03-3623-0433
http:/www.omine.com/

Photo/ 品田良子

東京桐木櫃

有著美麗直木紋的桐木櫃，展現出江戶時代的傳統與職人的技術。其中，東京桐木櫃用的，是將日本國內最高級的會津桐自然乾燥後製成的優質桐材。

自古以來，桐材因有調節濕氣的作用，且具有優秀的耐火性，而被視為重寶。空氣潮濕的日子能將戶外空氣隔絕，而乾燥的日子則有良好的通風性。桐材一旦吸收水分便會膨脹，煙無法滲透，因此不容易燃燒。

即使經過長年使用，也能整修成新品一樣，可以使用一輩子。

Craftsmen use highly textured, straight-grain wood from the kiri, or paulownia tree, to create striking traditional Japanese chests. Tokyo paulownia chests incorporate the beautiful grain and superb luster of naturally dried Aizu paulownia-the finest in Japan. The unique structure of paulownia wood minimizes humidity and mildew to protect the chest's contents, while the structural quality of the wood makes it naturally fire resistant. Because they are meticulously cared for and can be restored as necessary, paulownia chests last a lifetime.

TOKYO KIRITANSU

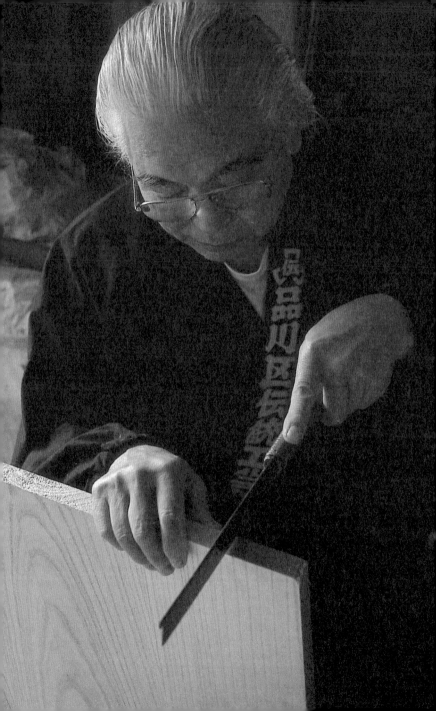

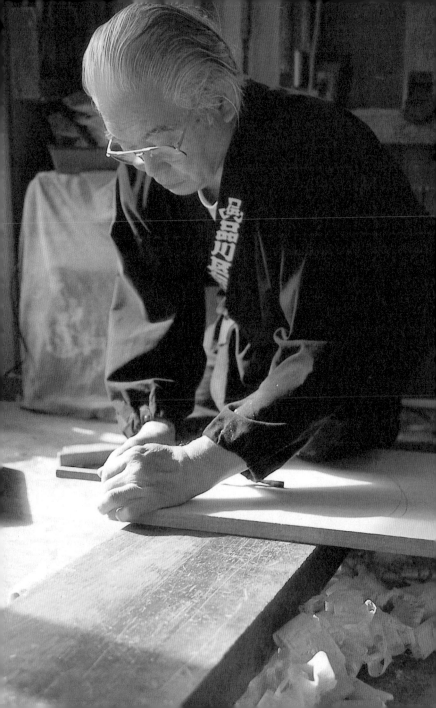

合資会社林タンス店
林 正次 (はやし まさつぐ)

傳統工藝士、東京都優秀技能者。昭和30年，身為家業繼承者，開始在父親身邊開始修行。從材料開始，即顯現出職人技術之講究，因桐材相當不容易到手，所以只要聽說有好的木材，不管是哪裡都會親自前往。在製作抽屜時使用鳩尾榫等獨特的技術，不愧是大師。也製作了國立歷史民俗博物館及東京江戶博物館等處保管歷史資料的大型收納櫃。對於桐木櫃的執著，也好好地傳給了兒子，也是第三代繼承者的英之先生。「這輩子永不退休」朝氣蓬勃的職人如此說道。

Masatsugu Hayashi is a superb traditional craftsman, and a recipient of the prestigious Tokyo Master designation. He was raised in the family chest- and cabinet-making business, trained in the craft under the direction of his father. Mr. Hayashi developed a very discerning eye for the materials he uses-every bit as important as his skills as an artisan. His work has also made him an accidental traveler of sorts: whenever hard-to-find paulownia comes onto the market, he must be ready to go get it, wherever it may be.

P164
削板時，連一張紙的差距都毫不妥協。

合資会社林タンス店
東京都品川区二葉 2-22-6　　TEL：03-3782-1821

Photo/ 中山雅照

江戸刺繡

飛鳥時代佛教傳到日本，當時以刺繡繪製佛像，也就是所謂的「繡佛」，即為日本刺繡的起源。

平安時代，在貴族社會中，刺繡開始被運用在十二單（譯注：貴族女性最正式的禮服）等的裝飾上，爭相鬥艷著。

而在安土桃山時代，則併用了「染め」、「絞り」等其他職人技術。

接著，天下太平的江戶時代，陸續誕生了絢麗多姿的和服，京風、加賀風、江戶風等表現當地風情的花紋，各有其特色。

「江戶刺繡」隨著江戶的繁榮而興盛，昭和62年，被認定為傳統工藝品，由現代的職人們繼續傳承下去。

Shishu embroidery in Japan began with the introduction of Buddhism and the importation of embroidered Buddha images in the Asuka Period. Japan's history can be seen in its shishu embroidery-incorporated in the junihitoe, or 12-layer unlined kimono worn by the noblewomen of the Heian Period, and the magnificently embroidered kimonos that appeared during the Edo Period.

EDO SHISHU

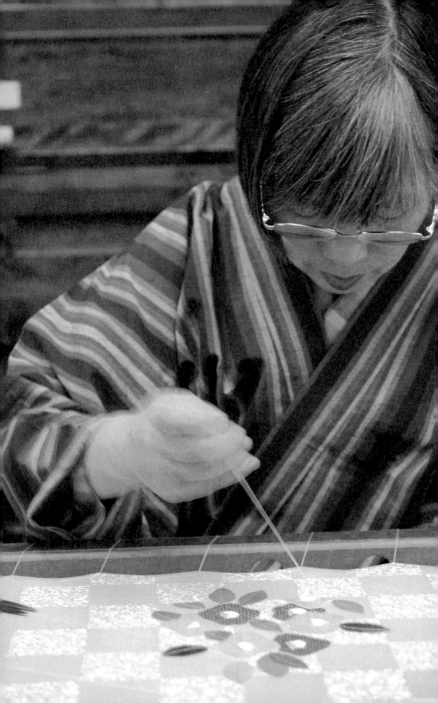

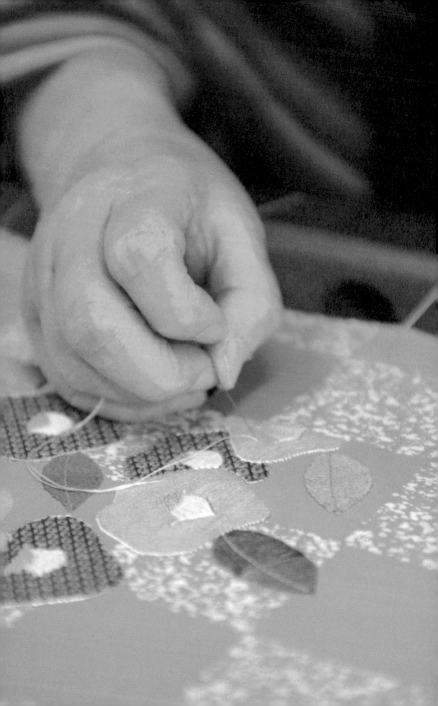

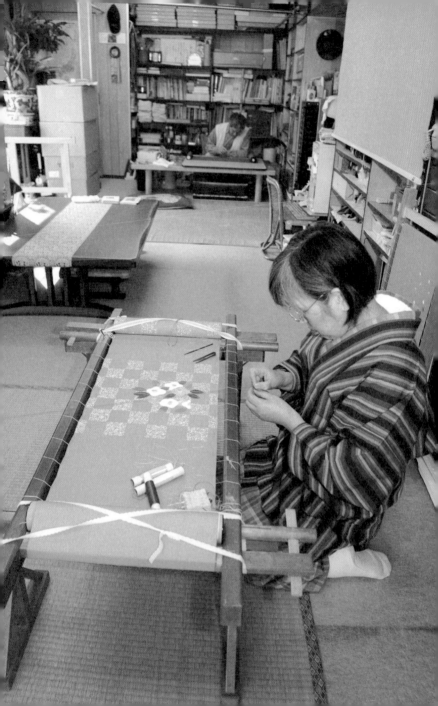

江上工房
江上芳子（えがみ よしこ）

1943年出生於東京。2002年被認定為東京都傳統工藝士。大多數的刺繡職人會請圖案師繪製圖案，或是直接刺在友禪印染上。而江上小姐則是在和服、腰帶、小飾品上自己設計圖樣後，再行刺繡，所以作品皆是獨創。也常與手繪友禪傳統工藝士（國家認定）的丈夫——江上昌幸合作。在江上工房，相繼誕生出美麗的染製品及刺繡作品。

Born in Tokyo, Yoshiko Egami was certified as a traditional artisan by the Tokyo Metropolitan government in 2002, for her design and embroidery of kimono, obi, and accessories (komono). While all her work is original design, she is famous for her many collaborations with friend and yuzen (printed silk) master Masahiko, herself certified as a traditional artisan by the government of Japan. Their works are an exuberant marriage of the nation's best embroidery and dyeing artistry.

P167
「江戸刺繡」的特色在於考量到線的粗細，纏繞的鬆緊度等，自行捻線的技術。

P168
「釜糸」為取自於蠶繭的絹線，捻成一股後使用。

P169
由丈夫染製的市松花紋的布匹上，一針一針地刺出自己設計的圖樣。

P170
在江上工房工作時的模樣。位於後方的是手繪友禪傳統工藝士的丈夫。

江上工房
東京都練馬区土支田 2-30-18　TEL：03-3921-1207
http://egamikobo.fc2web.com

Photo/ 佐藤純子

江戶木雕

木雕的歷史久遠，據說始於6世紀佛教傳到日本之際。平安時代至鎌倉時代雕刻出了許多佛像，當不用佛像的禪宗達到全盛期時，裝飾神社寺廟的欄柱、窗框等的建築雕刻則急速發展。建築雕刻原本是由木工雕製的。到了江戶時代，從木工師傅中，出現了專事裝飾的宮雕師。江戶木雕師繼承了其歷史，現在於置物櫃、喪葬用具、建築雕刻上展現技術。

Woodcarving has a proud history, dating back to the arrival of Buddhism in Japan. Originally, carpenters did all the architectural woodcarving in the nation's shrines and temples. However, as the art advanced and became more elaborate during the Edo Period, woodcarving work was taken over by miyaborishi, specialists in the art of woodcarving decoration. Edo woodcarvers continue this tradition, keeping alive the carving techniques handed down over the generations.

EDO MOKUCHOKOKU

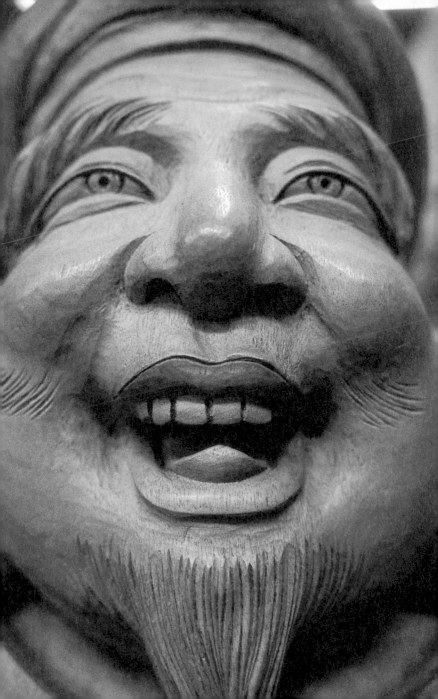

園田神佛具店
園田秀夫（そのだ ひでお）

昭和16年出生於葛飾區柴又的一間神佛雕刻店，園田先生在佛像的包圍下長大。師事父親，學習木雕，之後繼承了園田家雕刻師之名「園田正信」。成為第三代後，至今仍延續其傳統。出了柴又站後，職人園田先生所雕刻的木雕介紹板便映入眼簾。從明治時代維持至今的神佛具店，就位在帝釋天的入口處。也與隔壁的民藝品店合作，販售名為「はじき猿」的鄉土玩具。

Hideo Sonoda was born in Shibamata, Katsushika Ward, Tokyo in 1941. Like many families in this enclave in the capital, the Sonodas were plying a traditional trade, running a shop specializing in Shinto and Buddhist woodcarving. Hideo grew up surrounded by Buddhist statuary. He trained in the woodcarving arts under his father, eventually attaining the level of artistry to assume the name Masanobu from the senior Sonoda and pass on the family tradition. Today the third-generation woodcarver looks back at his work with pride and forward with anticipation.

園田神佛具店
東京都葛飾区柴又 7-6-14　TEL：03-3657-5997

Photo/ いち

東京雕金

雕金的歷史悠久，因裝飾於刀劍上的器具、刀鍔等金屬零件而興盛。

使用多種依作品用途所製的鑿子，擺動鑿頭，雕刻金、銀、白金、銅等金屬素材。技法則有毛雕、蹴雕、象嵌、高肉、薄肉、肉合雕、透雕等。

明治9年，政府頒布了廢刀令及禁止使用貴金屬的七七禁止令，而雕金製品隨著社會的變化，如今多轉換為珠寶飾品等製品。

Japanese-style metalwork, or chokin, arose from the military tradition, beginning with decorative hand guards, scabbards and other sword accoutrement. Early metalworkers developed an array of chisels and other tools, each designed to create a different class of product or application. Adjusting the positions of the implements enabled metalworking craftsmen to grind, chisel and file to a fine finish gold, silver, platinum and copper. Most chokin specialists today are producing jewelry.

TOKYO CHOKIN

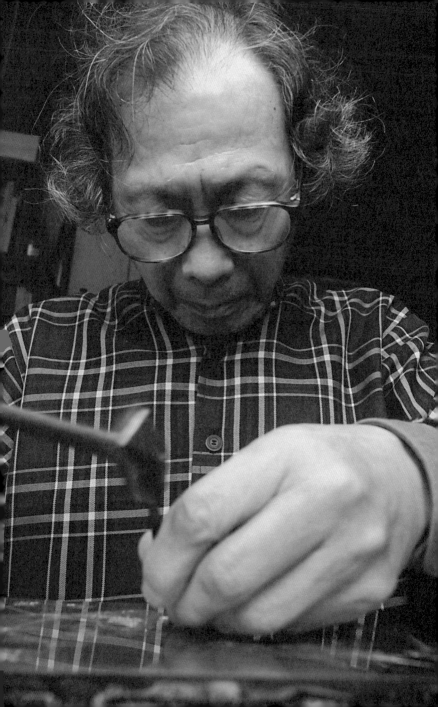

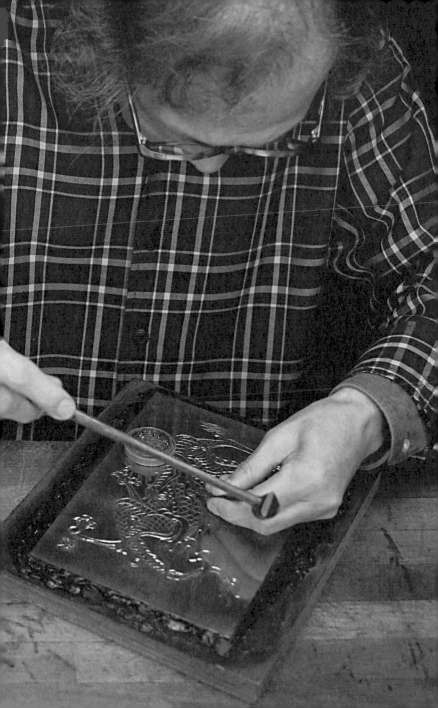

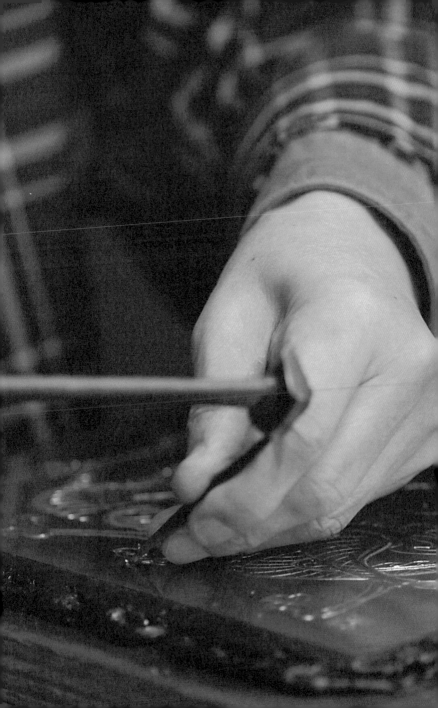

清水彫金工房
清水洪政（しみず こうせい）

東京都傳統工藝技術保存連合會豐島地區會員。1936年出生於福島縣。1947
年師事雕金家柿島義鄉。1950年成立清水雕金工房。為日本雕金會委員、審
查委員。J.C.C會員。東京都傳統工藝師士。擁有豐島區傳統工藝士認定資
格。號香政。獲得傳統工藝士認定後，每天翻閱著古書，研究雕金的起源及
流派。

Kosei Shimizu was born in Fukushima prefecture in 1936, and, while
still an 11 year-old child, began to study under metalworking master
Giko Kakishima. By 1950, he already had a hand in establishing the
Shimizu Metalworking Craft Center. He is a member of the Judging
Committee of the Nihon Chokin Kai, and sits on another of the nation's
key metalworking organizations, the J.C.C. Mr. Shimuzu is officially
recognized as a traditional craftsman of Tokyo, and of the Toshima
Ward. He has taken the master's name Kasei.

P178-179
桌上擺著手工做的鑿子。

P180
在作品上精準地雕刻著。

P254-256
拇指大小的Nikon F3。看得出洪政先生的玩心。

清水彫金工房
東京都豐島区駒込 7-10-9　TEL：03-3917-9487

Photo/ 纐纈哲広

181

東京刀剪

鍛治技法約在1500年前左右傳到日本。爾後，此技術經過刀劍職人的琢磨，發展出著鋼法，以軟鐵鍛造，並在刀刃部分打上鋼，質軟且鋒利，日本獨有的刀剪就此誕生。

到了太平盛世的江戶時代，則利用刀鍛治的技術，轉型成製作日常生活運用刀剪的町鍛治。也就是變成製作業務用、家用的刀剪。

Blacksmithing was introduced to Japan some 1,500 years ago, and was advanced technically and artistically by sword craftsmen, who forged uniquely Japanese, soft, sharp blades. These techniques were then further perfected by artisans working to develop blades for everyday civilian uses in the Edo Period.

TOKYO UCHIHAMONO

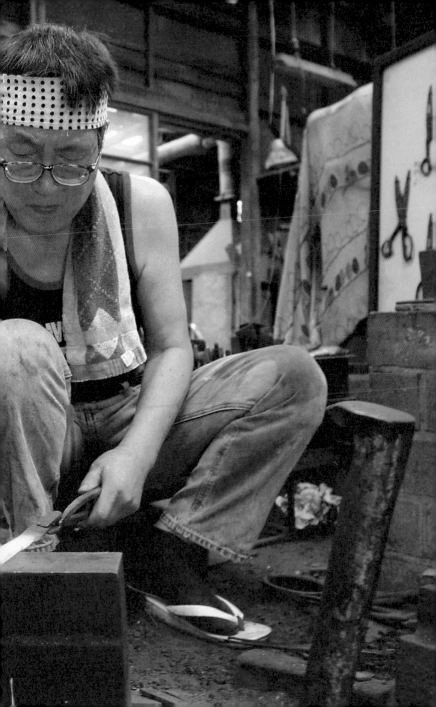

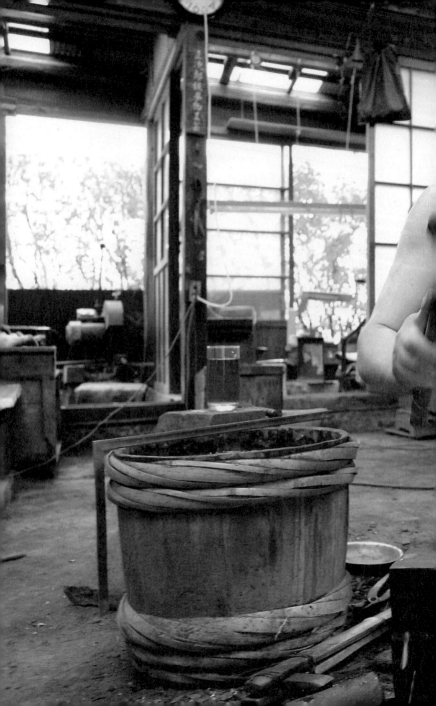

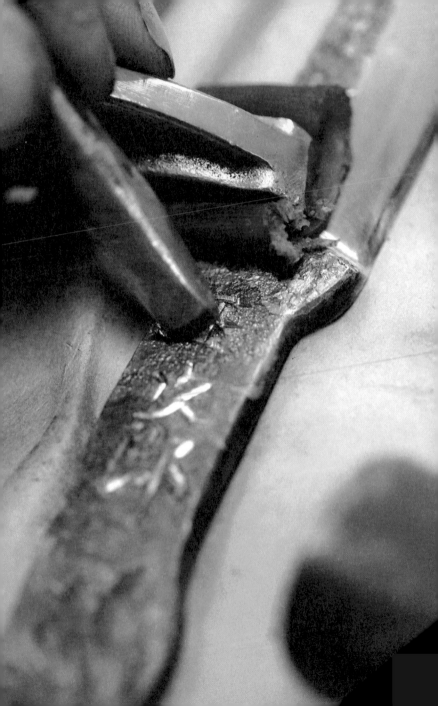

正次郎鋏刃物工芸
石塚洋一郎（いしづか よういちろう）

54年前，在千葉縣成田機場附近設立工房。出生於江戶時代後期就開始製作刀剪的世家，19年前繼承工房，並改名為第五代正次郎鋏刃物工芸。洋一郎先生講究將刀柄、刀刃過火後，以手工打製的「総火造り」之技法，秉持著「愛好真品的人絕不會消失」的理念，精心製作萬用菜刀及小型刀。

Yoichiro Ishizuka was born into a family of sword- and cutlery-makers with a pedigree stretching back to the late Edo Period. He established his own workshop near Narita Airport in Chiba Prefecture, where he has been producing fine cutlery for the last 54 years. Later, he assumed the title of Shojiro Hasami Hamono Kogei, becoming the fifth-generation master of the sword- and blade-making arts. Although Mr. Ishizuka primarily produces all-purpose kitchen knives and smaller cutlery, his craftsmanship remains true to the proud techniques that date back to the feudal swordmasters.

P184-185
鍛冶的過程相當重要，敲打時必須將錘子的接觸面維持水平，只要稍微有些歪斜，就會傷到刀身。

正次郎鋏刃物工芸
千葉県成田市松崎 697　TEL：0476-26-8061
http://www.shojiro.com/

Photo/ 泉 三郎

東京刀剪

明治初期，江戶改稱為東京，從事製造刀劍的鍛冶職人，順著廢刀令與文明開化的潮流，轉為製作業務用及家用刀剪。運用日本刀的製法，僅以鐵槌將一塊軟鐵打製成刀剪，鋒利度與刀劍不相上下。擁有引以為傲的鋒利度，東京刀剪為許多職人、廚師長年愛用品。

Few in Japan were more profoundly impacted by the radical changes of the Meiji Restoration than swordmakers. With the decree banning the wearing of swords in 1876, these craftsmen had to switch to industrial and household forged blade production. However, subsequent generations of craftsmen continued applying the techniques of the sword-making masters to create some of the world's highest quality forged blades. Today, cooks and homemakers are among the beneficiaries of Japan's feudal sword-making tradition.

TOKYO UCHIHAMONO

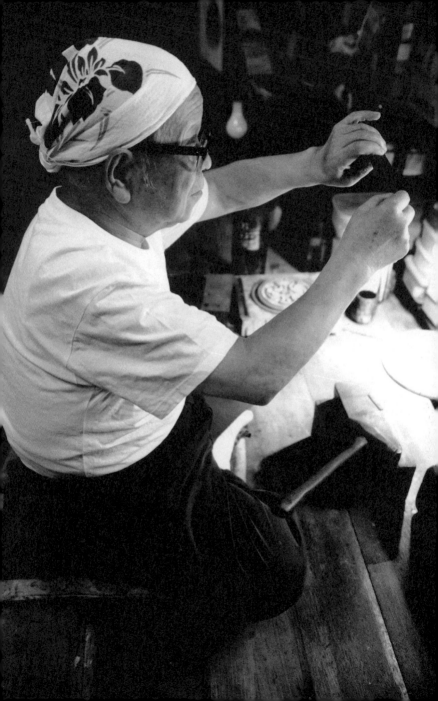

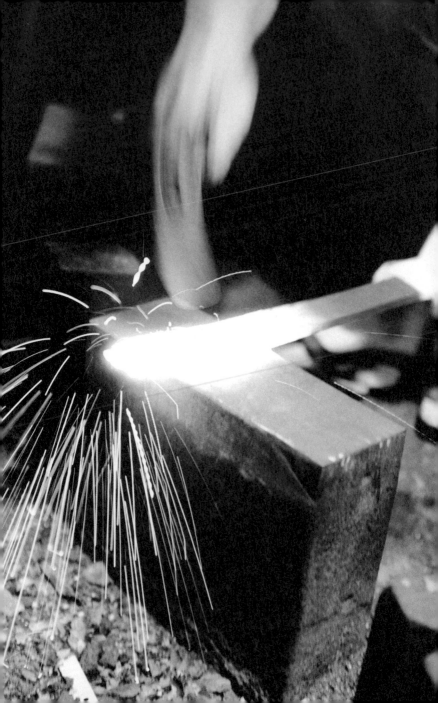

和弘利器株式会社
大河原辰雄（おおかわら たつお）／**大河原享幸**（おおかわら たかゆき）

大河原岑雄、享幸兩兄弟守護著傳統「総火造り」的技法。15歲入門，往後兩兄弟持續鍛造長達70年。已有許多媒體採訪報導兩人默契十足的「打ち合い」。並在全日本各地的會場實際操演，將刀剪的魅力傳給現代人。「菜刀可以憑力氣製作，但刀柄是只有經驗跟力氣是不行的。沒有塑型的才能是行不通的」職人如此說道，而今天也在東京金町，不停地揮著槌子，發出聲響。

The Okawara brothers, Tatsuo and Takayuki, remain true to Japan's traditional sobizukuri blade forging methods. Since becoming apprentices at the age of 15, the two have been making forged blades for 70 years, developing the chemistry that is obvious to anyone watching them work together today. They demonstrate their craft at exhibitions across the country, working to share the appeal of the blade-making arts.

和弘利器株式会社
東京都葛飾区金町 1-10-8　TEL：03-3607-0833

Photo/ 笠原好美

江戶裝裱

所謂的裝裱，為以布、紙黏貼，作成捲軸、掛軸、書畫帖、屏風、隔扇等的一項工藝。其歷史相當悠遠，在日本已有千年之久，透過各個時代的有名、無名師傅的手藝，抵抗時代的洪流，得以傳承至今。

平成元年，「江戶裝裱」獲東京都政府認定為「傳統工藝品」，職人們也將繼續致力於將此發展成獨具匠心的新技術。

Scrolls take many forms in Japan, including kakemono hanging paper or cloth scrolls, scrolls of calligraphy, folding screens and the paper coverings for sliding fusuma doors. In addition, paintings and calligraphy are finished as scrolls in a mounting process known as hyoso or hyoko in Japanese. After 1,000 years of artistic history, the scroll-making was certified as a traditional craft in 1989. Today, artisans continue building on the tradition, creating innovative new styles of scroll art.

EDO HYOGU

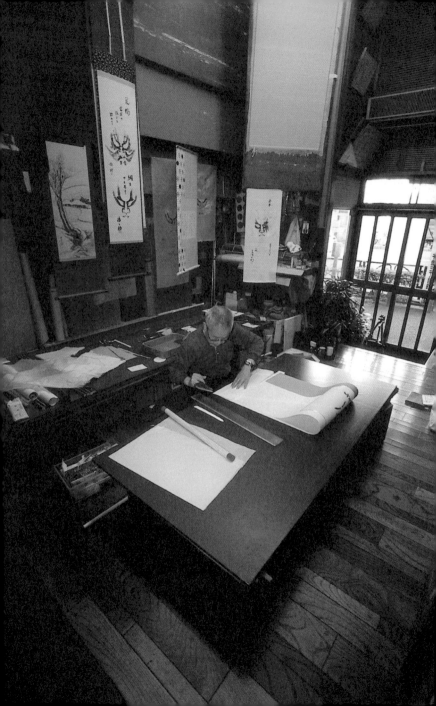

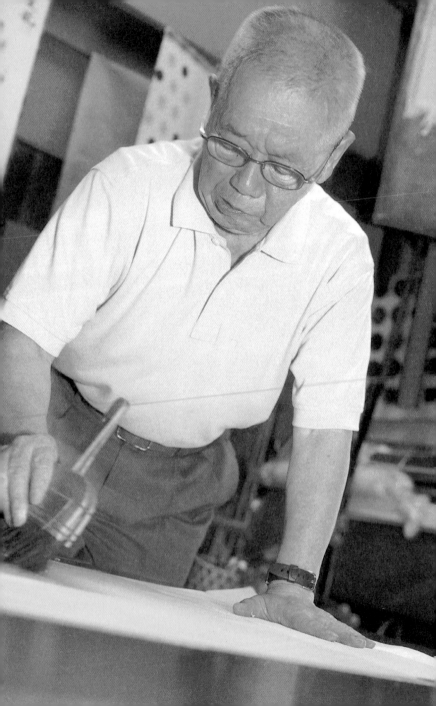

表具師前川
前川八十治（まえかわ やそぢ）

前川八十治繼承上一代彌太郎先生的技術，進到裝裱的世界後，已活躍了50多年。平成4年獲得「墨田區登錄無形文化財」之認定。數量眾多的作品當中，歌舞伎臉譜的裝裱可稱為職人前川的代表作。「珍惜與顧客間的緣分」如此說道的前田先生也提到「裱裝匠需要的不只有技術，還要有美感與品味」。正是如此，職人才需不停地磨練、精進自己的本領。

Yasoji Maekawa succeeded his father and mentor Yataro, becoming a scroll artist more than 50 years ago. After decades of superb work, he was recognized by Sumida Ward, Tokyo in 1992, when his skills were declared an intangible cultural asset. He is perhaps best known for his kumadori scrolls of kabuki faces.

P193
在本紙上重複粘上好幾層襯紙，製成可半永久保存的堅固掛軸。是一道相當講求技術的作業。

P194
依照當天的天氣、氣溫、濕度調整漿糊的濃度。此作業需要職人的直覺。

表具師前川
東京都墨田区千歳 3-5-11　　TEL：03-3631-0508

Photo/ 山田宏次郎

東京三味線

三味線據說始於從中國傳到琉球的三弦。室町時代末期，從琉球傳到泉州堺後（譯註：現大阪府西南部），改以撥子彈奏，琴體則以貓皮等製作。江戶時代，隨著清元節、長唄的流行，江戶也盛行製作三味線。三味線的構造大致上可分為纏弦處的弦倉、琴桿、以及蒙著皮的琴身等三部分。製作工程中，蒙皮的步驟是決定三味線音色的重要工程，因此需要相當熟練的技術。

The shamisen originated in China, and was introduced to Japan in its original three-stringed form through the Ryukyu Islands. The strings are wrapped around a pegbox (itogura), close to the fingerboard, which is of one piece with the neck. The soundbox is covered with animal skin, typically dogskin, catskin or snakeskin. A shamisen's sound quality is determined by the way this skin is attached to the soundbox, a process that requires exacting technical skill.

TOKYO SHAMISEN

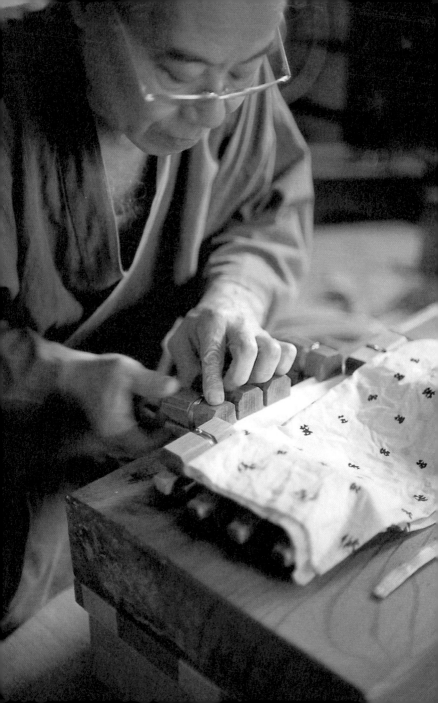

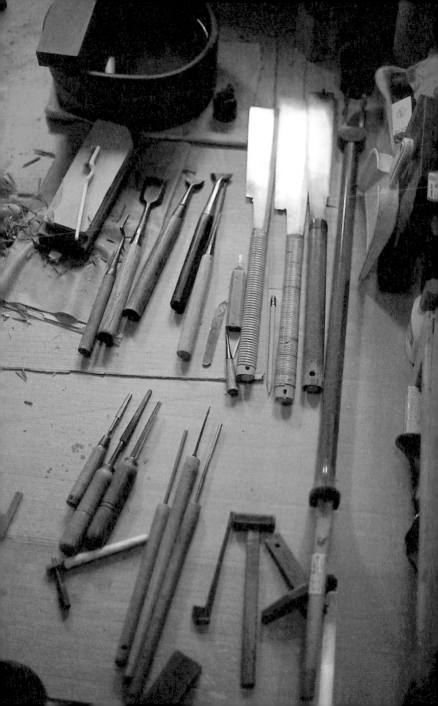

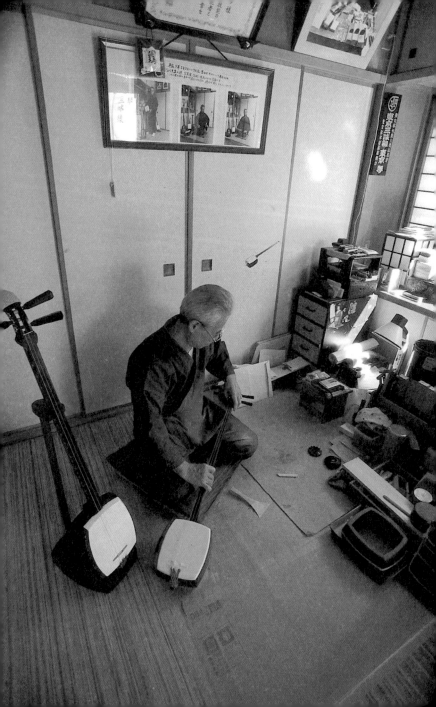

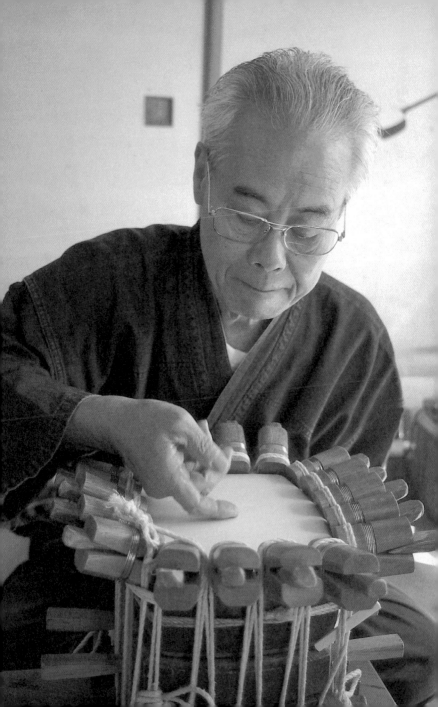

菊音邦楽器店
野口哲彦（のぐち てつひこ）

雖然父親也為三味線職人，但野口先生最初也有在外工作的經驗。最終因為認為自己「個性不適合替人工作」，而選擇走上職人之路。雖然製作三味線的業界如今也開始分工化，但野口先生是少數能獨自進行所有工程的職人。據說製作過程中最需要用心的蒙皮作業，會避開在下雨等天氣惡劣的日子時進行。野口先生不僅製作三味線，也在當地的國中教授日本傳統音樂，並致力於日本傳統音樂的普及。雖年逾古稀，但仍意氣軒昂。

Tetsuhiko Noguchi's father is a shamisen artisan. Noguchi himself originally worked as a regular company employee, but was eventually drawn to follow his father on the path of shamisen craftsmanship. At the time, shamisen production had become specialized, with different craftsmen handling different parts of the process. Noguchi became one of very few artisans capable of creating a shamisen entirely by himself. In addition to his making the instruments, he teaches Japanese music at a local school, working in both capacities to keep the music of Japan thriving.

P197
使用木栓、繩、楔子等道具，在能承受的範圍內，將蒙在琴體上的皮撐開到極限。

P200
最後進行細微的調整，以指尖輕敲皮的表面，根據音色以及觸感調整鬆緊度。「全憑感覺」——野口先生如此描述這個步驟。

菊音邦楽器店
東京都文京区千駄木 5-38-1　　TEL：03-3821-2806
http://www.h4.dion.ne.jp/~kikuoto/

Photo/ 酒井裕司

江戶毛筆

江戶時代中期，隨著商人崛起，「私塾」也急速增加，毛筆也普及於民間。因此，江戶毛筆職人們的技術也跟著進步，誕生了許多江戶名筆。

相對於關西製作的「固め筆」（譯註：以糊將筆毛固定的毛筆），江戶毛筆基本上是「捌き筆」（譯註：出廠時筆毛便為散狀）。無論是粗還是細筆，即使將筆頭壓到底，筆尖依舊不會散開，無論何時都可以寫出細線。

Writing and drawing were relatively esoteric skills until the mid-Edo Period, when terakoya schools were established to provide education to commoners. Just at the point average citizens began using writing brushes, Edo craftsmen were improving their brush-making techniques. The watershed event in the development of the Edo writing brush was the creation of the sabakifude, a brush without a core and no starch applied to the head. Sabakifude brushes-large and small-collect at the tip to enable the user to write consistently fine lines.

EDO FUDE

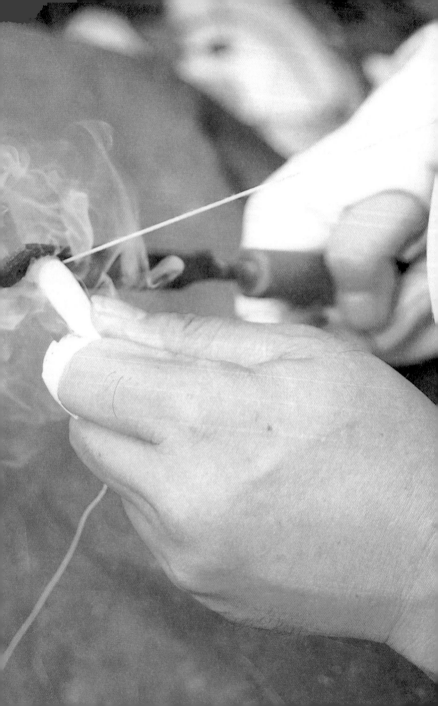

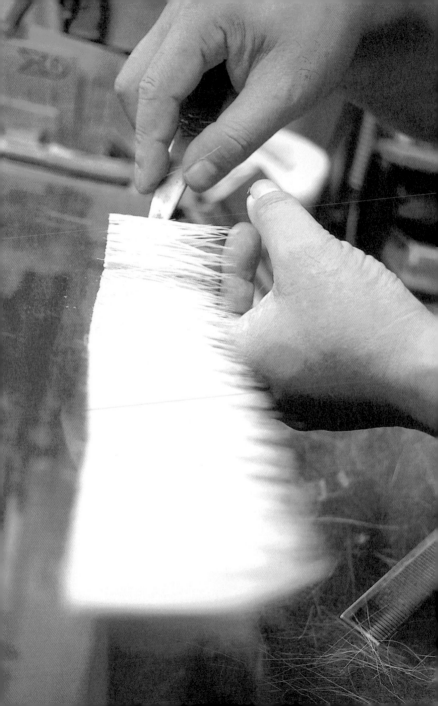

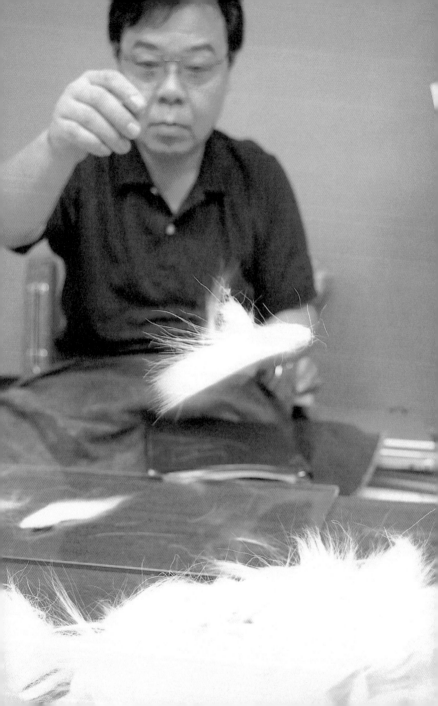

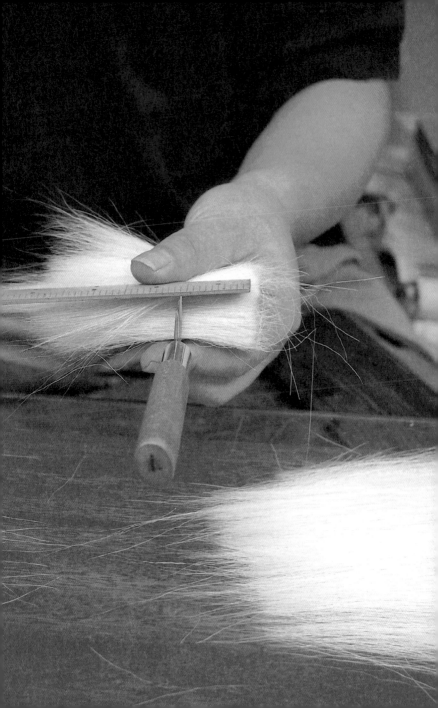

筆工房亀井
亀井正文 （かめい まさふみ）

亀井先生為第四代，繼承了明治10年代至今的技術、技法。製作了850多種毛筆。製作毛筆時會依照書法家的喜好、技術。如珍惜使用的話，可以用上20年～30年，也有提供修理毛筆的服務。總有一天想只製作自己喜歡的毛筆，而兒子曉央先生（27歲）還有6、7年才能獨當一面。亀井先生盼望著那一天的來臨。

Masafumi Kamei is the fourth in a line of writing brush artisans, inheriting techniques going back to 1877. He produces about 850 different types of writing brushes, each geared to the needs and skills of the individual calligraphers for whom they are made. Kamei writing brushes can be repaired, and owners of a Kamei take meticulous care of it. Thus, it is common for a brush to be used for 20, even 30 years.

P203
「尾締め」將毛料的根部用麻線綑綁後，以熱鐵板燙熨，並趁熱紮緊。

P204
「練りまぜ」將塑好型的筆頭分成5～6個一組，並梳揉到一致。

P205
「選別」用眼睛以及觸感確認，依照不同用途，挑揀毛長、筆尖的好壞。

P206
「丈分け」按照需求，將不同長度的毛料大致分開。

筆工房亀井
東京都練馬区石神井町 5-14-2　TEL：03-3996-5046
http://www016.upp.so-net.ne.jp/fudeya/

Photo/ 齋藤真理

東京素染

日本傳統民族衣裳「和服」，其中最為基本的染製法，便是素染。

素染為將布料一一染製成顧客訂製的顏色，而正因為是素色，其最大的特徵便是重染時會有很好的效果。

製作過程大致可分為檢查、過水、染色、對色、水洗、乾燥、整理、再檢查等許多手工作業，需要職人熟練的技巧。

The kimono is one of the nation's most celebrated symbols, Japan's traditional costume. At its heart, the kimono is a triumph of dyeing technique. In patternless dyeing, each piece of fabric is dyed separately, to the specification of the order. Because it is patternless, the dye can be changed in mid-process, a defining feature that adds freedom and flexibility to kimono design. Kimono dyeing is largely performed by hand, an exacting process that demands the finely honed skills of experienced craftsmen.

TOKYO MUJIZOME

中央染工
大坪俊男（おおつぼ としお）／**高須 保**（たかす たもつ）／**鈴木信子**（すずき のぶこ）

中央染工擁有引以為傲100年歷史，由初代在京都創業，而上一代藉著在東京開設分工場的機會，將陣地轉到東京。現在，由第四代的西島先生與夫人，以及三位入行40餘年的老手們一同經營工場，守護著傳統文化。

The Chuo Dyehouse was founded 100 years ago in Kyoto. Fourth-generation dyemaster Toshio Otsubo relocated to Tokyo when the family established a kimono factory in the capital. Today, Mr. Otsubo is working with his wife and three veteran artisans-each with more than four decades of experience-to keep the traditional kimono arts thriving.

P209
將染好的布料掛在竿子上乾燥。

P210 上
以蒸氣機熨燙，固定布料的寬度及長度。

P210 下
使用專門的道具將布料鋪開，並固定好形狀。

P211 上
染製完的布料經過檢查，仔細地卷好後便是完成品。等著送至批發商。

P211 下
「はりて」（將染好的布料乾燥時使用的道具）

P213 左
有許多落語家愛用著東京素染的和服。圖為落語家立川談四楼先生，身穿中央染工染製，帶有家徽的和服。

中央染工
東京都中野区本町 6-27-17　TEL：03-3382-4116

Photo/ 井上雅恵

東京素染

素染（浸染）為自古以來最基本的染色法，以熬煮草木後取得的汁液染色，也稱為草木染。藍花、紅花等染色材料與佛教一同傳來，同時也確立了染色技術。鐮倉時代，因媒染液的發達而有相當大的進步。到了江戶時代，因江戶染紫為歌舞伎演員團十郎扮演助六時愛用的頭巾，而普及於民間。現代則因科技進步，開始使用化學染料。素染可將一件和服反覆重染，能享受很多種顏色，所以經常是由母親傳給女兒繼承。

Patternless dyeing is derived from the most fundamental and ancient method of coloring fabric-boiling out the natural dyestuff from plants and soaking the cloth in the extruded dye. More sophisticated dyeing technology and the use of indigo blue and safflower red came to Japan with the arrival of Buddhism. However, as modern science and technology developed further, natural plant dyeing techniques began giving way to the chemical processes that predominate today.

TOKYO MUJIZOME

山本染工房
山本敬治（やまもと けいじ）

山本先生為從事素染55年以上的老手。20年前設計出了名為夢想暈的色調。使用親手做的特殊工具裝配布料，並為了染出美麗的層次，不停變換布料的染色部分以及染液的顏色，花上3天至1個禮拜的時間才能完成。夢想暈的名稱，乃因山本先生在心目中描繪的想法實現之前，真的是「連做夢都夢到」，而以此命名。目前與弟弟豐美先生一同經營浜田山的工房。

Keiji Yamamoto has been plying the art and craft of patternless dyeing for some 55 years. A little more than 20 years ago he conceived the musoun dyeing method for a more sophisticated, nuanced coloration. It involves setting the cloth up on a special device he designed himself, and applying a meticulous and time-consuming dyeing technique, designed to produce beautiful color gradations. His subtle but striking creations are the centerpiece of the traditional Japanese clothing factory that Yamamoto runs, along with his brother Toyomi.

P215
山本先生所設計的夢想暈。

P216
確認染好的布料的顏色。

P217
排得滿滿的瓶子，裡面裝著溶解後的染液。

P218
為了對色，將一部分的布料（壓在熱水通過的管子上）弄乾。

山本染工房
東京都杉並区高井戸東 4-26-1　　TEL：03-3332-1134

Photo/ 鈴木貴美子

東京琴

江戶末期由山田流的創始者——山田檢校改良而成的東京琴。比從前的琴身稍短，長約6尺。而琴的厚度偏厚，「ムクリ」（縱向的弦）也較強，所以聲音相當大。琴所使用的材料有桐木、紅木、紫檀等。而琴弦則是使用絹線。因琴爪做得較大，其特徵為明亮的音色。一般的琴分成山田流與生田流，但東京琴不問流派，被廣泛地使用著。

The first Tokyo koto was created by Kenko Yamada, the founder of the Yamada school, an alternative approach to koto performance in the late Edo Period. The Tokyo koto is slightly shorter than its traditional predecessor, measuring six shaku, or about 1.8 meters, whereas the original koto is closer to two meters long. In addition, the Tokyo version is thicker, and distinguished by a more robust, clearer sound. It is made from materials including paulownia, ruby wood and red sandalwood, with silk threads used for the strings.

TOKYO KOTO

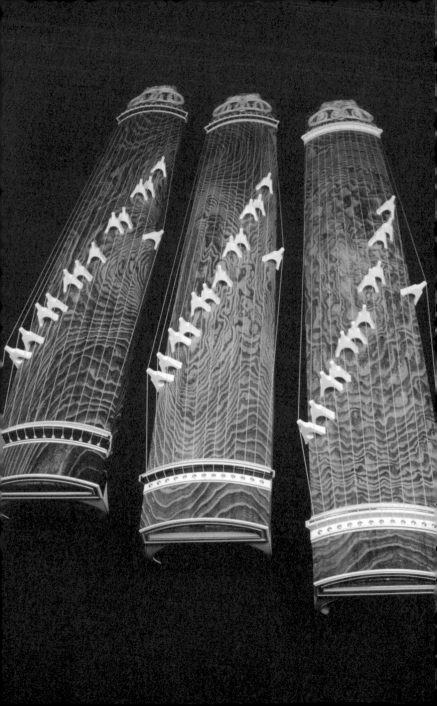

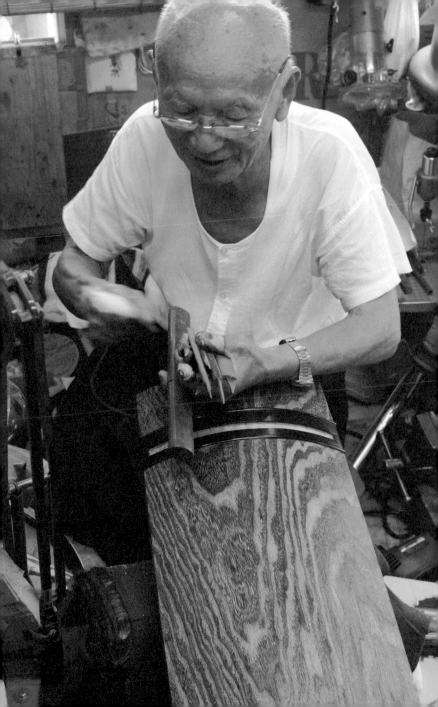

かねこ琴三絃楽器店
金子誠次（かねこ せいじ）

金子誠次先生，是日本少數包辦從原木到一把琴完成為止，所有作業之琴職人。講究使用桐（會津桐）的原木製作至今80年，其音色深植人心，令人難忘。從他的話語中，能感受到將一生奉獻給江戶琴的人才有的自信和尊嚴，以及對琴滿滿的愛意。

Seiji Kaneko is one of the few artisans in Japan capable of creating a koto from the hollowed out trunk of a paulownia tree without assistance in any of the processes involved. He has been carefully selecting paulownia for 80 years, turning the wood into vibrant yet reflective music that leaves an indelible impression on the listener.

かねこ琴三絃楽器店
東京都大田区千鳥 3-18-3　TEL：03-3759-0557
http://www.kanekogakki.com/

Photo/ 近藤和寿

依照加飾技法，製作江戶唐紙的職人，大致可分為「唐紙師」、「砂紙師」、「印花紙師」等三種。而其中的唐紙師是採用「木版手摺り」，將名為雲母的繪具放在版木上，再鋪上和紙，印出圖樣，此為最傳統的技法。

隔扇、屏風、壁紙等，江戶唐紙的用途相當廣泛，如今在日本建築的裝潢上也是不可或缺的素材。

Edo karakami artisans produce three main varieties of decorative paper: karakamishi, sunagoshi and sarasashi. There are a variety of methods for creating the signature decorative patterns; which one is chosen depends on the type of paper to be made, and its application. Since the Edo Period, karakami has been employed for a wide variety of uses, including fusuma - sliding doors constructed of wooden frames and covered with layers of thick paper - and byobu folding screens. It is an essential part of Japanese interior design and construction.

EDO KARAKAMI

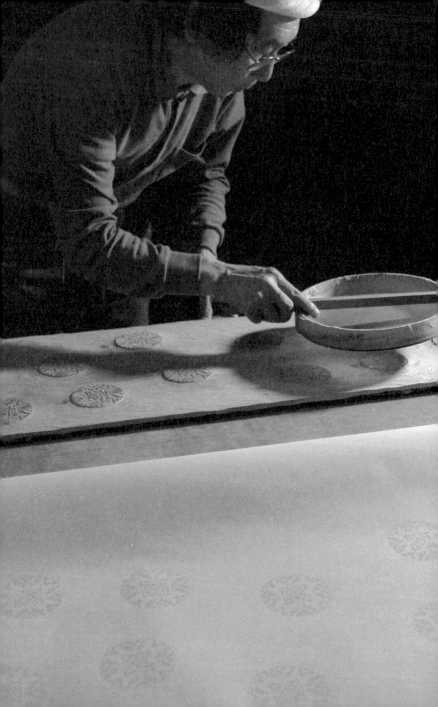

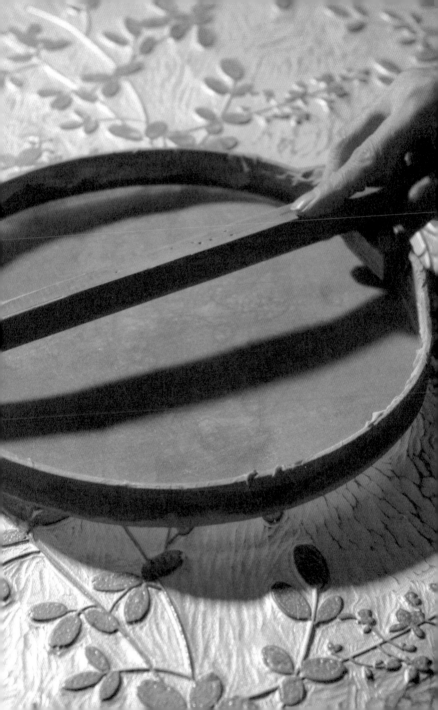

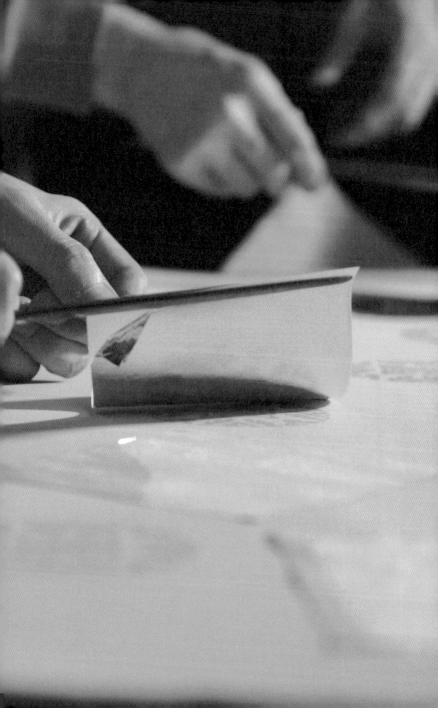

株式会社小泉襖紙加工所
小泉幸雄（こいずみ ゆきお）

從小便在工作場中，看著同為唐紙師的父親的背影長大。一邊幫忙之中，也自然地入了此行，據說過了30歲便負責了大半的業務。平成13年2月，與父親一同獲得傳統工藝士之認定。現在則是每天與兒子兩人一起工作。「雖然還比不上父親，但我想做出最好的東西」。

Yukio Koizumi grew up watching his father, a master karakami artisan, working in his shop. Once he began helping his father, it was just a short step to a career in the profession. By the time he reached 30, was already responsible for half of the shop's output. Father and son were recognized together as traditional craftsmen by the government of Japan in February 2001.

P227
在「浮線蝶」花紋的版木上，以篩子塗上糊。版木為幸雄先生自己雕刻複製而成的。

P228
在「荻」花紋的版木上擺上雲母。之後蓋上和紙，以手刷印製出花紋。

P229
沾有糊的花紋上貼上金銀箔，乾燥後再磨平，使花紋浮出的加飾技法「箔飾り」。

P230
「春挙松」花紋的壁紙（鶴岡八幡宮・齋館「有朋亭」）。

株式会社小泉襖紙加工所
東京都文京区湯島 1-10-13　http://www.tokyomatsuya.co.jp
株式会社小泉襖紙加工所　TEL：03-3816-0925
株式会社東京松屋ショールーム　TEL：03-3842-3785

Photo/ 阿部タカノリ

江戸木版畫

木版畫的歷史相當久遠，約1200年前隨佛教一同從中國傳入。用於翻印教典與佛畫等印刷技術為其起源。

江戶時代中期，鈴木春信發明了多色刷製的錦繪，由繪師、雕版師、刷版師三人合力製作的浮世繪就此誕生。到了明治、大正時代，因印刷技術機械化，木版畫印刷一時式微，但因其絢麗的藝術性，成為海外備受好評的傳統工藝品，木版畫漸漸開始復興。

此後，木版畫便聞名全世界。

Colorful woodblock prints, or hanga, are the culmination of centuries of development. Originally developed in China, woodblock printing came to Japan with the arrival of Buddhist missionaries from China, and began with the printing of Buddhist holy scriptures. It reached its pinnacle in the mid-Edo Period with the birth of the ukiyo-e or "floating world" -rich multicolor compositions illustrating the urban lifestyle of the time. Although woodblock printing eventually fell into decline, it became a highly valued art form overseas, and remains an international symbol of Japan.

EDO MOKUHANGA

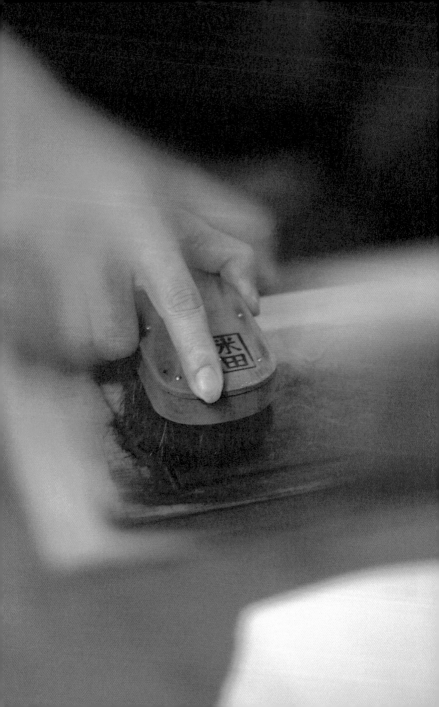

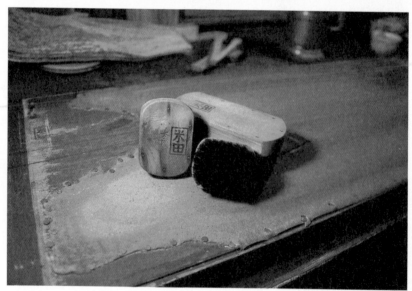

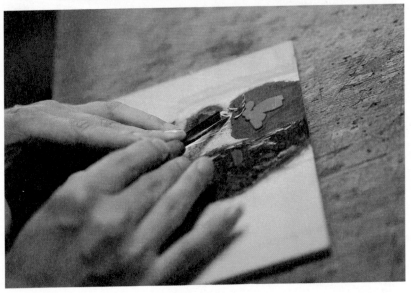

米田版画工房
米田良二（よねだ りょうじ）

出生於1962年。東京木版畫工藝協會會員、重要民族文化財保存技術保持者、浮世繪木版畫雕摺技術保存協會會員、練馬區傳統工藝會會員。1980年師事父親米田稔，直到現在。平成6年獲得東京都青年優秀技能者知事賞。即使至今已修業20年，米田先生仍熱血地說著「到死都要學習」。米田版画工房設有教室，教授木版畫、雕版、刷色、碑拓刷色、以及企劃、製作等。

Ryoji Yoneda studied under the guidance of his father, Minoru, from 1980. By 1994 he was honored with a youth award for artistic excellence by the governor of Tokyo. Although he has now trained and worked for over 20 years, Yoneda is only beginning: he speaks of his training in the art as an ongoing process that will end only when he dies. At his workshop he is a one-man team, drawing the picture pattern, carving the woodblock to resemble the picture, then applying the ink to the woodblock for printing onto paper. When he is not working, he organizes projects and runs woodblock printing classes to further the art.

P233
浮世木版畫使用櫻花木，現代木版畫則是使用欅木或雛木。為了調出想要的顏色，要在版下（刻版前貼在版上的草稿）一次又一次地重複疊上顏色。

P234 上
作品完成後，會吊在工房的天花板上晾乾。
到這個步驟，可是花了不少時間與勞力。

P235 上　噴霧器與4色的畫具
上色是最困難的一個步驟，甚至有「木版畫職人為上色掉淚」這句話。調出稱為「どぶ色（井鼠色）」的顏色需要長年的經驗。

P236　馬簾（譯註：刷色時在紙背上反覆摩擦的工具）
「遇到災難的時候，要立刻帶著馬簾跑走」馬簾正是木版畫師的生命。米田先生的馬簾，是以竹皮以及纖維自己製作的。

米田版画工房
東京都練馬区豊玉南 2-25-13-404　TEL：03-3994-3534

Photo/ 足立百合

東京七寶

所謂的七寶，指的是佛典裡的「金、銀、琉璃、水晶、硨磲、瑪瑙、珍珠」，而七寶燒則因宛如這些寶物般高貴而得名。

過去曾將七寶搗碎製成釉藥使用，如今技術進步，改為在石英中加入有機金屬（氯化銀）等調和而成，能表現更多色彩，且不容易損傷，並更加耀眼。

東京奧運的徽章、領帶夾、袖扣，或是身邊常見的中小學的校徽等，無論是誰都曾經接觸過這項工藝品。

Shippo, the Japanese term for cloisonn literally means "seven jewels," referring to gold, silver, crystal, lapis lazuli, amber, agate and pearl, referenced in the Buddhist scriptures. The term likens the beauty of the enameling on metalwork to the priceless Seven Treasures. Well-known cloisonn products include pin-badges, tie pins and cuffs.

TOKYO SHIPPO

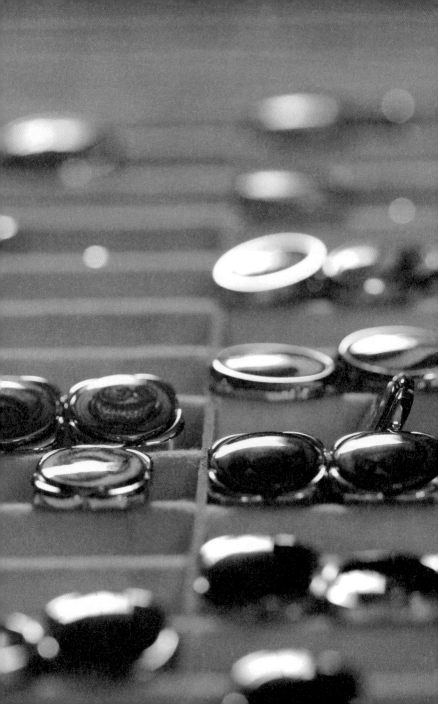

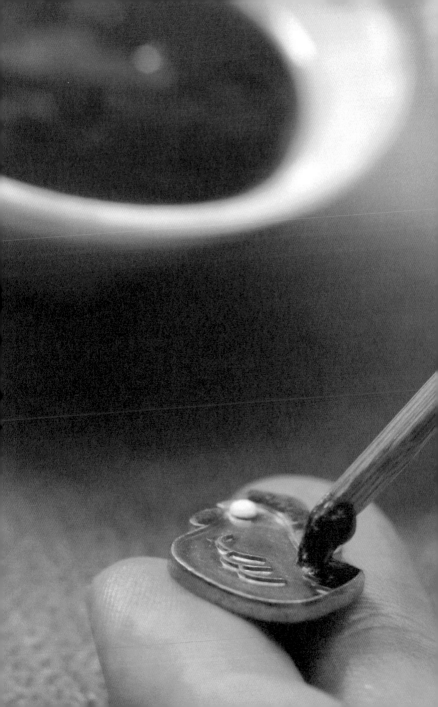

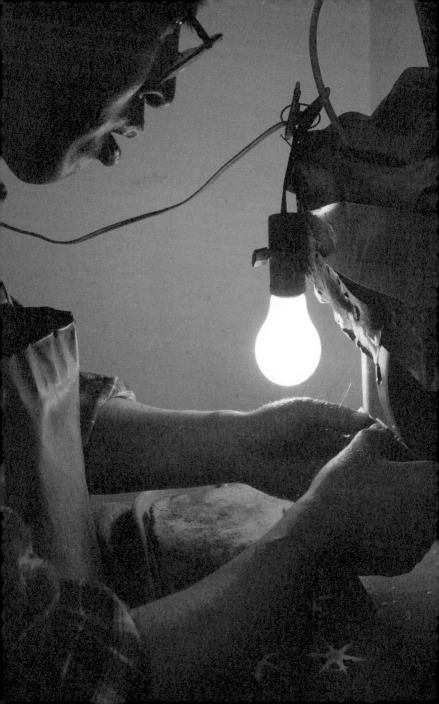

畠山七宝製作所
畠山弘 （はたけやま ひろし）

1953年出生於東京南千住。大學畢業後，為了繼承家業，而花了10年學習七寶燒的基礎。之後也習得了設計七寶和使整體協調的課程。另外也著手研究東京七寶以外的七寶技法。平成14年，東京七寶被認定為東京都傳統工藝。平成16年，畠山先生於七寶設計部門得到東京都產業勞動局長賞。成為職人28年後，平成17年獲認為東京都傳統工藝士。畠山先生創造的七寶製品，其色彩展現出無限的可能性。

Hiroshi Hatakeyama was born in Minamisenju in 1953. After graduating from university, he joined the family business and spent ten years learning the fundamentals of enameling and metalwork, eventually mastering cloisonn design and production techniques. He was officially recognized as a Tokyo Master Traditional Craftsman in 2005 for his seemingly limitless skills with modern cloisonn

畠山七宝製作所
東京都荒川区南千住 5-43-4　　TEL：03-3801-4844
http://www.tokyo-shippou.com/

Photo/ 瀬尾純子

江戶玻璃

在日本，製造玻璃的歷史可追溯到彌生時代。雖然曾一度停止製作，但之後又再度從葡萄牙、中國等地傳入。明治時代以後，東京為主要生產地。都內現在也有多間玻璃工廠。

隨著工業化的發展，職人們融合從歐洲傳來的技術，每天與玻璃爐的高溫奮鬥著，持續生產並提供各式各樣的手工製品與作品。

Glass production started in the Yayoi Period in Japan, but died out for a time until it was revived in the 17th century with vitrified glass products including bidoro and giyaman. Later, European glass technology was introduced and combined with indigenous Japanese techniques. Today, glassmaking artisans employ highly sophisticated skills to produce glass products of superb quality, as well as handmade works of art with applications in a variety of areas.

EDO GARASU

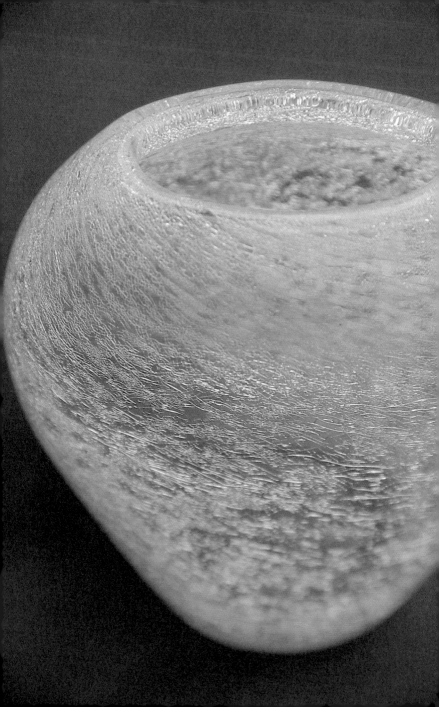

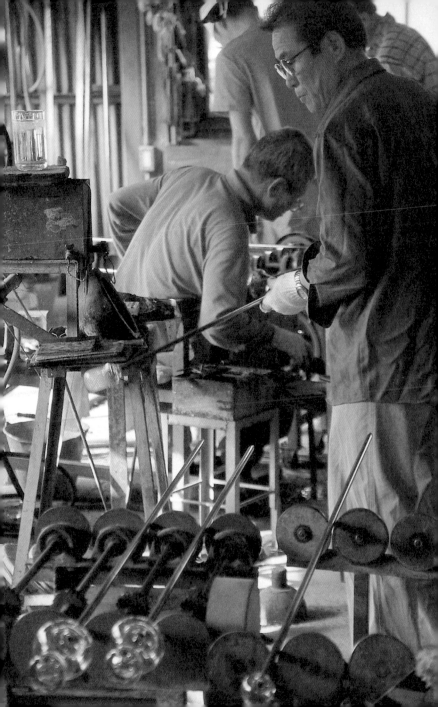

田島硝子株式会社
小西和男 (こにし かずお)

入行40年的老手。玻璃的製作方法有「宙吹き」「型吹き」等多種技法，皆需長年經驗的累積，以及高超的技術。由數名工作人員組成團隊，進行一連串的作業過程中，小西先生身為領導人，每天以熟練的技術努力著。工作的空檔也會指導後進，備受愛戴。不只是技術，其作品的藝術性也相當受到好評。

With 40 years experience, Kazuo Konishi is an acclaimed leader in his field, renowned for his artistry as well as his unsurpassed workmanship. Nevertheless, he continues working tirelessly to hone his skills further. When he is not actually creating glasswork, he is helping aspiring craftsmen with technical instruction.

田島硝子株式会社
本社：東京都江戸川区松江 4-18-8
TEL：03-3652-2727　http://www.tajimaglass.com

Photo/ 紀 彰雄

東京手植刷

日本最早的毛刷為塗漆用的工具（西元935年發行的「和妙類聚抄」中記載）。另一方面，刷子始於明治10年，第一次國內產業振興博覽會上，法國製的「洋製毛刷」。

隨著工廠機械化，出現了許多大量生產的刷子。但以手工一束一束仔細植入的刷子，比起機械植入的還要來的堅固又耐用。以熟練的技巧製作出的手植刷，靠著毛刷職人的雙手，傳承至今。

The first brushes of this variety were French-made items that appeared at an exposition held in 1877. Soon centers of brush manufacture arose in Japan, and mechanization eventually brought about mass production of the brushes. However, the bristles in hand-flocked brushes are more densely packed than their machine-made counterparts. They are stronger, and last longer.

TOKYO TEUEBURASHI

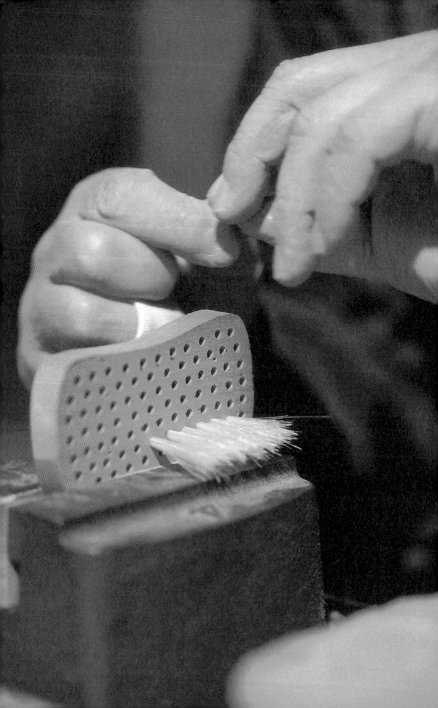

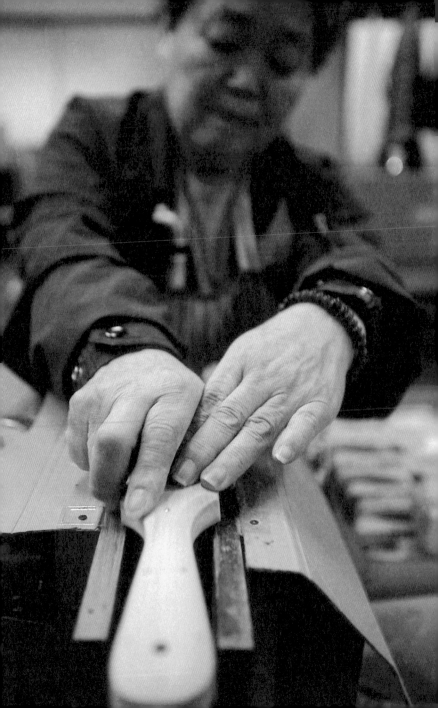

有限会社平野刷毛製作所
平野佳輝（ひらの よしてる）

大學畢業的同時繼承了家業，師事父親平野道孝，開始參與毛刷製作。在當時的塗裝作業中，需要許多塗漆用的毛刷。但是隨著時代變遷，毛刷業界也跟著衰退。此後，以品牌「ブラシの平野」開始生產家庭用的衣物刷等。活用傳統技法，講究於天然素材，也傾聽使用者的聲音，致力於製作使用方便又實用的刷具。

Upon graduation from university, Yoshiteru Hirano joined the family business under the tutelage of his father, Michitaka. At the time, there was a strong demand for painting brushes, but the painting industry has since declined. In response, the family expanded the business domain to include other products, such as clothing brushes. They manufacture and sell the line of brushes under the "Hirano Brushes" brand, which they also display in exhibitions across Japan.

P249
在桂木上開出一個一個洞後，將毛束調整成一樣的大小並仔細植入。職人技巧相當熟練。

有限会社平野刷毛製作所
東京都足立区西綾瀬 1-2-23
TEL：03-3852-5440
http://www.burashiya.com

Photo/ 足立百合

撮影師 一覧

Beretta P-05

由42位新銳攝影師所組成的攝影師團隊。全員皆畢業於「東京写真学園」專業攝影師課程。

東京写真学園／写真の学校

基礎理念為「拍照是一件開心的事。如果能學到更多拍照技術會更開心」，2000年10月於東京澀谷創校。專業級的大型攝影棚（三面）以及實景攝影棚等兩種實習攝影棚與專用暗房，擁有最佳的教學環境。

TEL:03-3400-4747
FAX:03-3400-4545
www.photoschool.jp
photo@shoto.co.jp

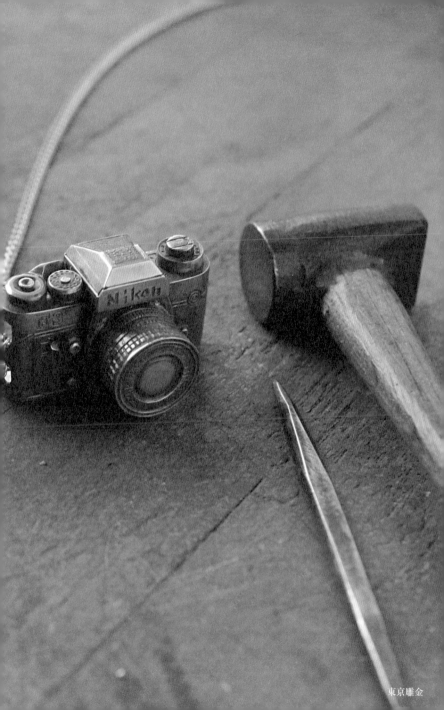

東京雕金

國家圖書館出版品預行編目(CIP)資料

東京職人 / Beretta P-05作 ; 汪欣慈翻譯.
-- 第一版. -- 新北市:人人, 2016.09
面 ; 公分. --(人人趣旅行 ; 48)
ISBN 978-986-461-060-0(平裝)
1.民間工藝 2.傳統技藝 3.傳記 4.日本東京都

969 105014014

JMJ

【 人人趣旅行48 】
東京職人

作者／Beretta P-05
翻譯／汪欣慈
校對／王凱潤
編輯／甘雅芳、陳宣穎
發行人／周元白
出版者／人人出版股份有限公司
電話／(02) 2918-3366 (代表號)
傳真／(02) 2914-0000
網址／http://www.jjp.com.tw
地址／23145 新北市新店區寶橋路235巷6弄6號7樓
郵政劃撥帳號／16402311 人人出版股份有限公司
製版印刷／長城製版印刷股份有限公司
電話／(02) 2918-3366 (代表號)
經銷商／聯合發行股份有限公司
電話／(02) 2917-8022
第一版第一刷／2016年9月
定價／新台幣300元

東京本染浴衣